CW01021311

HOW TO
Embroider
ALMOST EVERY ANIMAL

Inspiring | Educating | Creating | Entertaining

Brimming with creative inspiration, how-to projects, and useful information to enrich your everyday life, Quarto Knows is a favorite destination for those pursuing their interests and passions. Visit our site and dig deeper with our books into your area of interest: Quarto Creates, Quarto Cooks, Quarto Homes, Quarto Lives, Quarto Drives, Quarto Explores, Quarto Gifts, or Quarto Kids.

ONE POINT STITCH ANIMAL SHISHU
Copyright ©2016 applemints
All rights reserved.

Original Japanese edition published by E&G Creates Company Limited.
English translation and production rights arranged with E&G Creates Co., Ltd. through Timo Associates, Inc., Tokyo.
English language rights, translation & production by World Book Media, LLC
Email: info@worldbookmedia.com

©2021 Quarto Publishing Group USA Inc.

First published in the United States of America in 2021 by Quarry Books, an imprint of
The Quarto Group
100 Cummings Center
Suite 265-D
Beverly, Massachusetts 01915-6101
Telephone: (978) 282-9590
Fax: (978) 283-2742
QuartoKnows.com

All rights reserved. No part of this book may be reproduced in any form without written permission of the copyright owners. All images in this book have been reproduced with the knowledge and prior consent of the artists concerned, and no responsibility is accepted by producer, publisher, or printer for any infringement of copyright or otherwise, arising from the contents of this publication. Every effort has been made to ensure that credits accurately comply with information supplied. We apologize for any inaccuracies that may have occurred and will resolve inaccurate or missing information in a subsequent reprinting of the book.

Quarry Books titles are also available at discount for retail, wholesale, promotional, and bulk purchase. For details, contact the Special Sales Manager by email at specialsales@quarto.com or by mail at The Quarto Group, Attn: Special Sales Manager, 100 Cummings Center, Suite 265-D, Beverly, MA 01915-6101. USA.

10 9 8 7 6 5 4 3 2 1

ISBN: 978-1-63159-990-3

Printed in China

HOW TO Embroider ALMOST EVERY ANIMAL

A SOURCEBOOK OF 400+ MOTIFS & BEGINNER STITCH TUTORIALS

APPLEMINTS

QUARRY

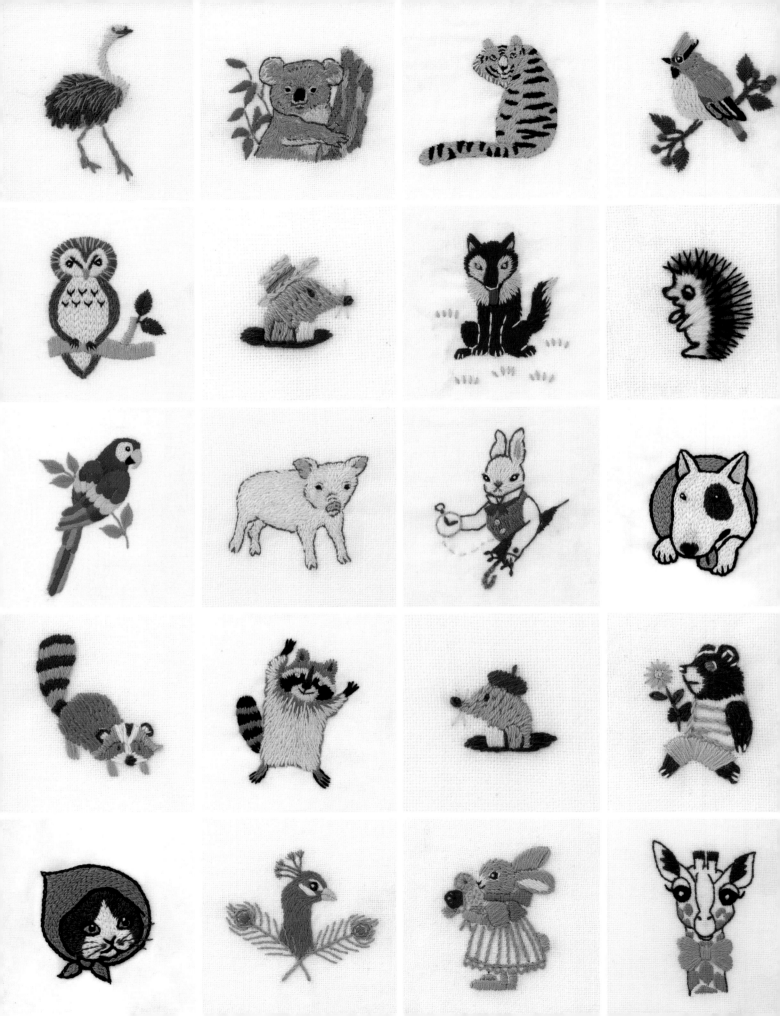

CONTENTS

At the Zoo

Instructions: pages 56–59
Design & Embroidery: Noriko Komurata

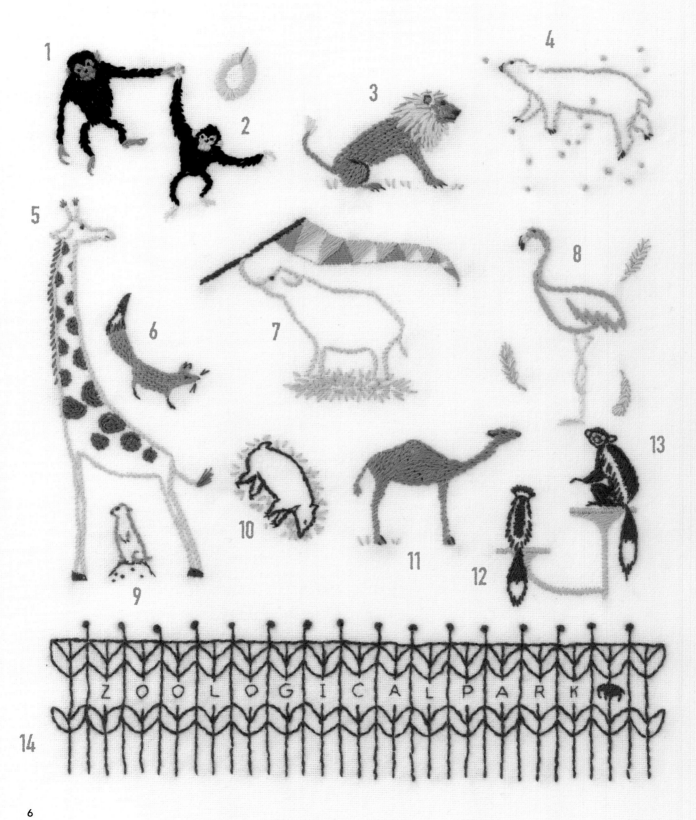

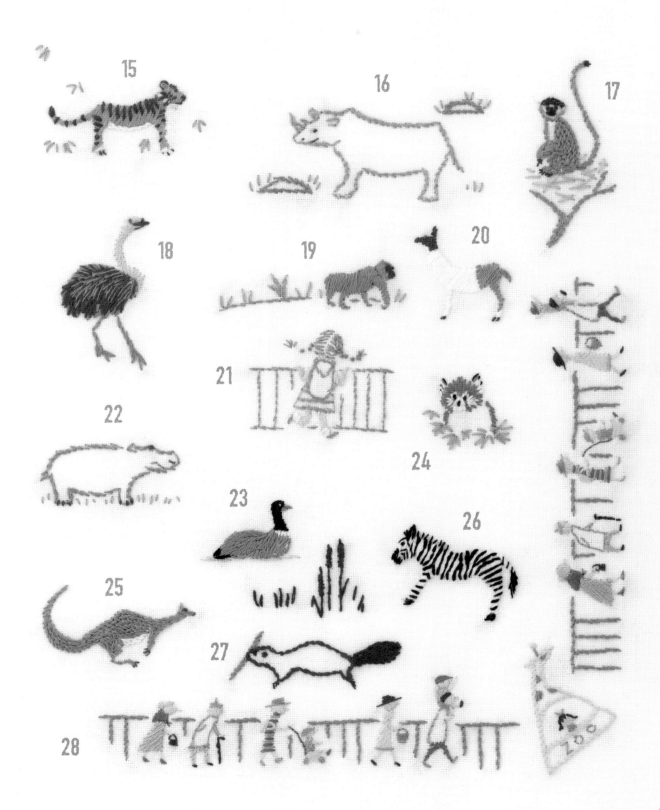

At the Zoo

Instructions: pages 60–63
Design & Embroidery: martinachakko (Hiroko Sonobe)

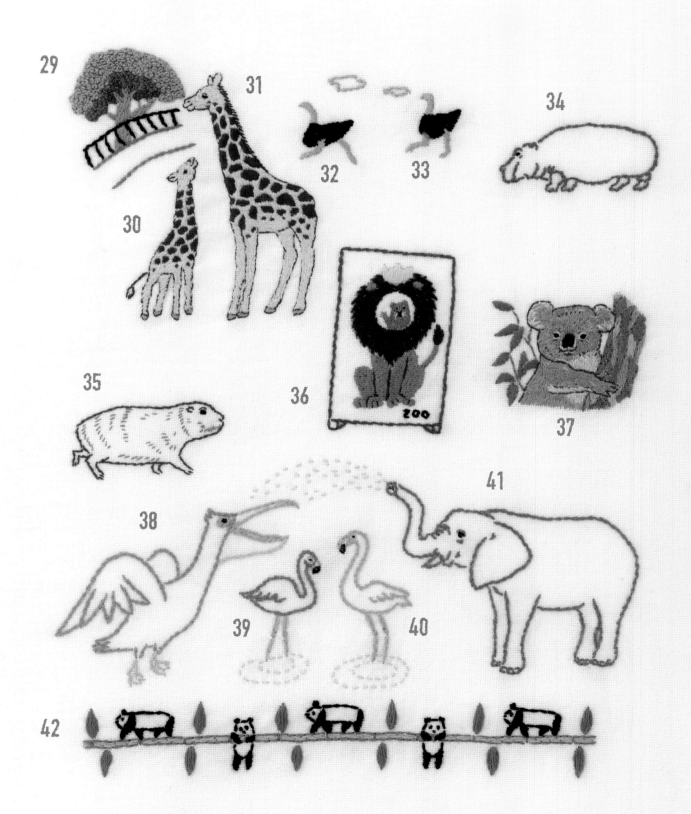

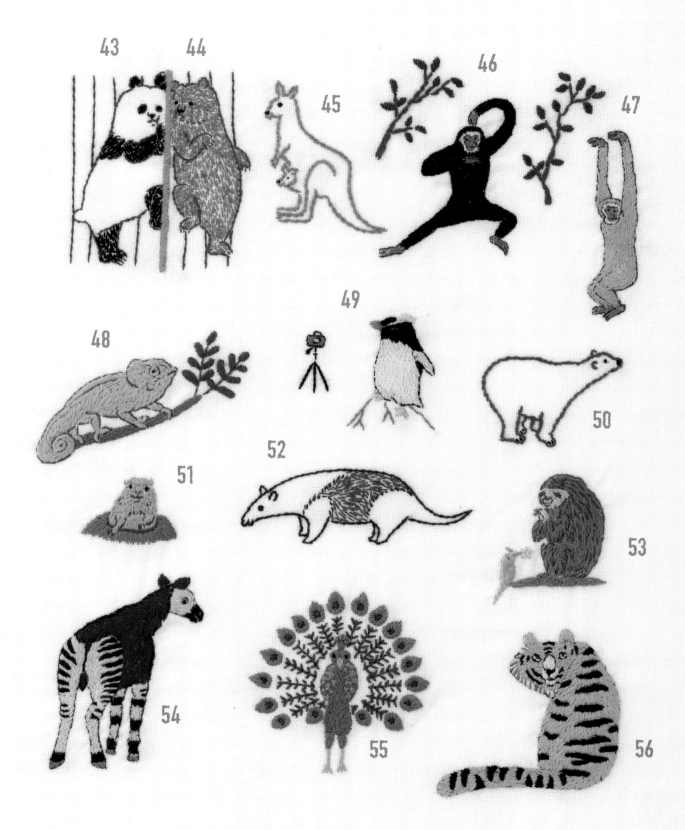

43 44 45 46 47 48 49 50 51 52 53 54 55 56

Visiting the Aquarium

Instructions: pages 64–65
Design & Embroidery: annas

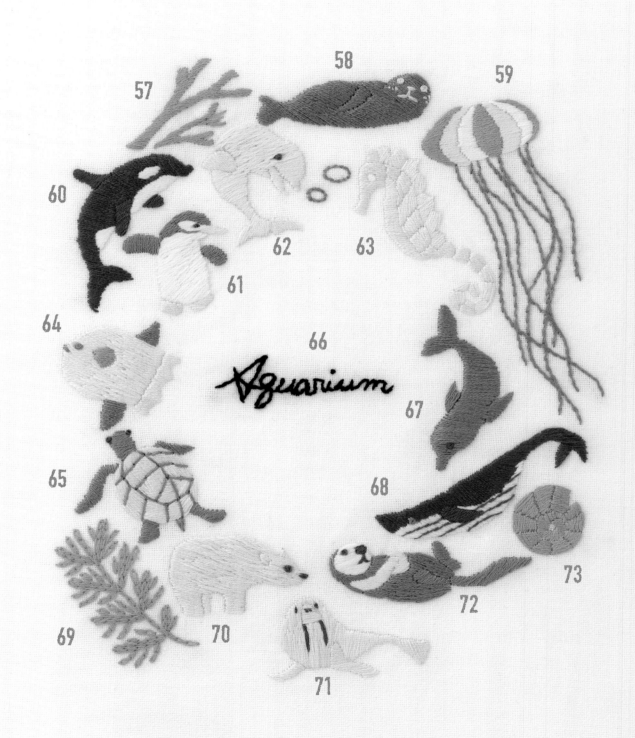

Mythological Creatures

Instructions: pages 66–67
Design & Embroidery: annas

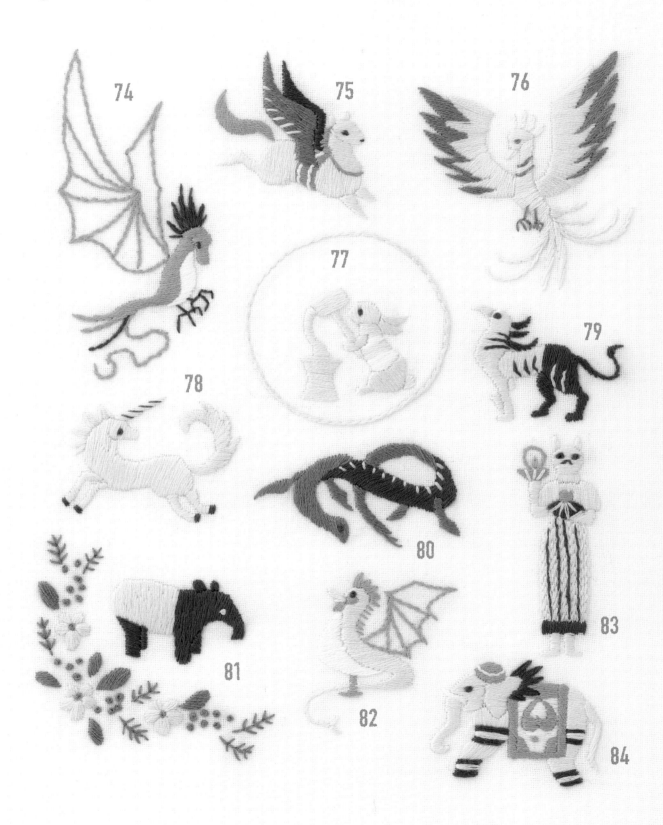

In the Forest

Instructions: pages 68–71
Design & Embroidery: siesta (Fumiko Saito)

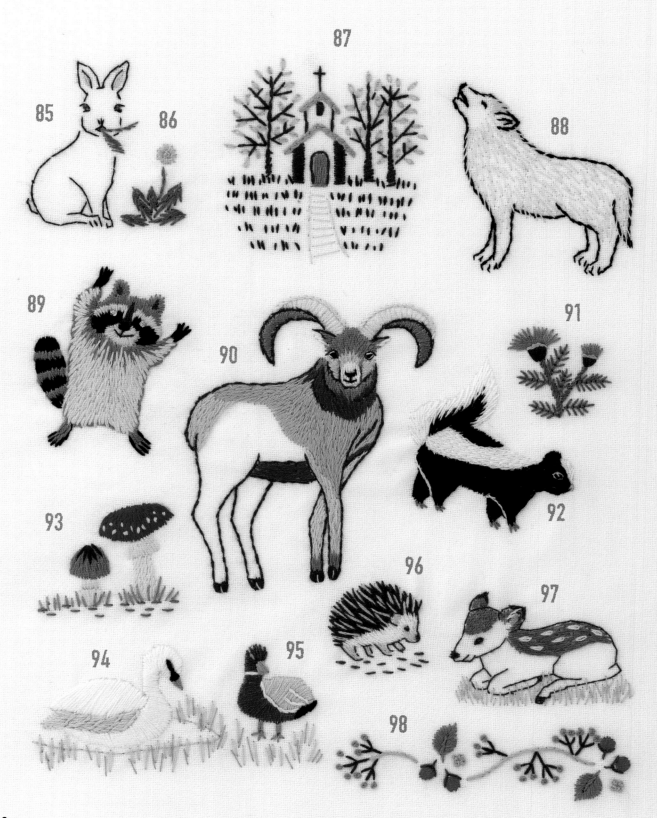

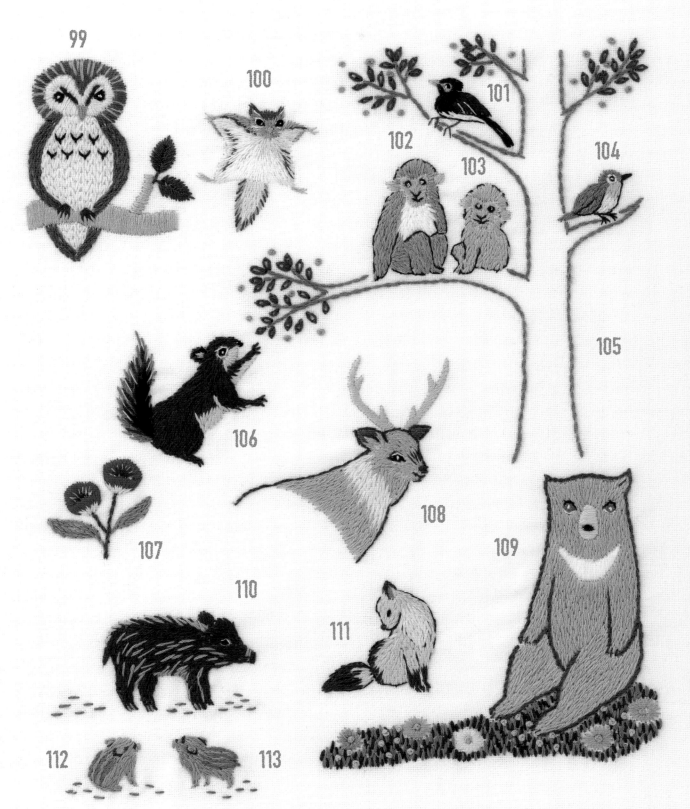

99

100

101

102

103

104

105

106

107

108

109

110

111

112 113

On the Farm

Instructions: pages 72–75
Design & Embroidery: martinachakko (Hiroko Sonobe)

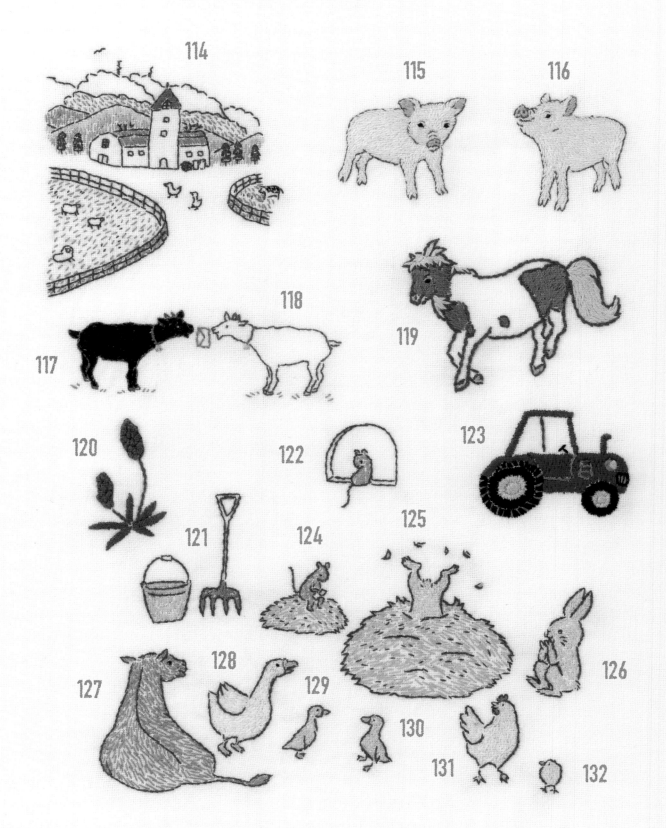

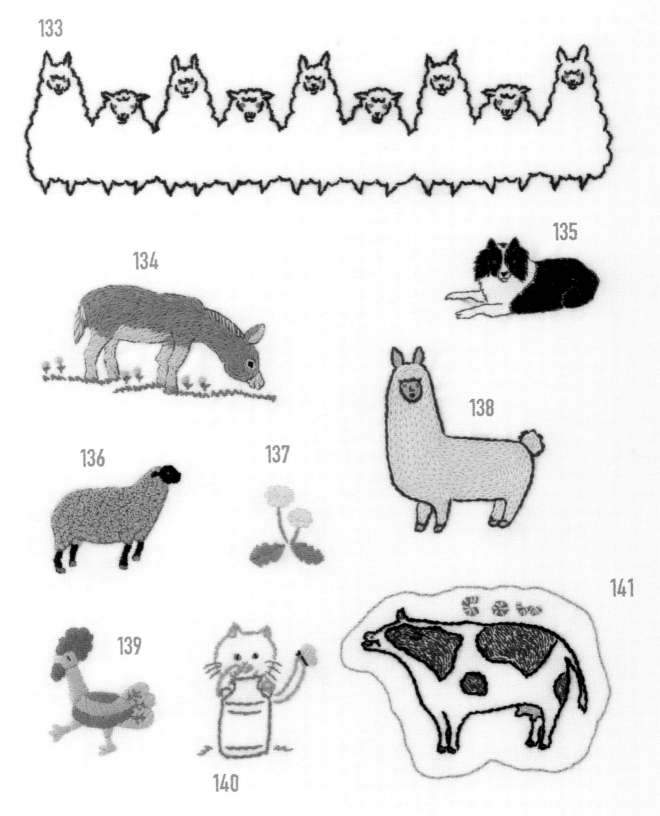

133

134

135

136

137

138

139

140

141

Small Creatures

Instructions: pages 76–79
Design & Embroidery: Sayuri Horiuchi

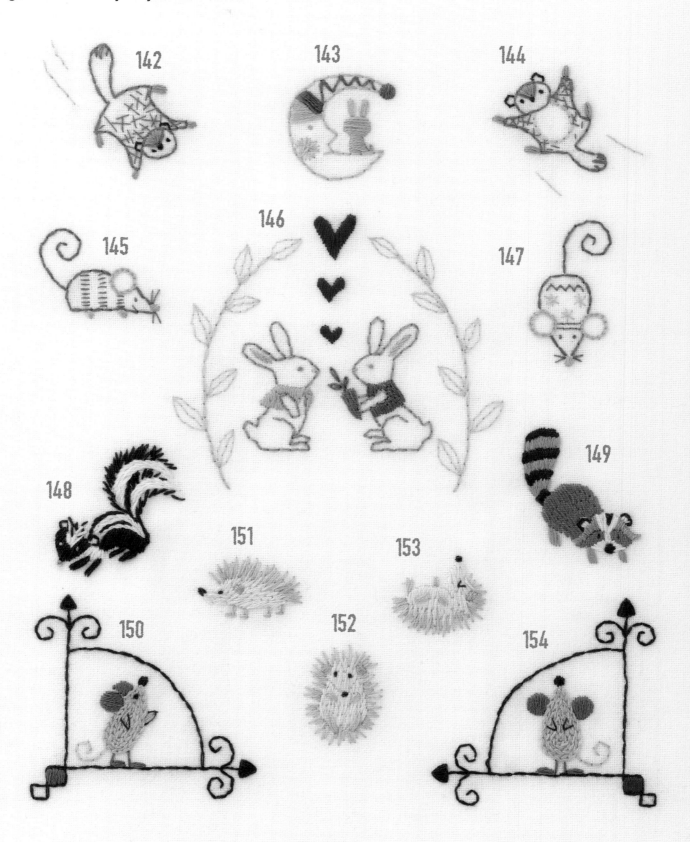

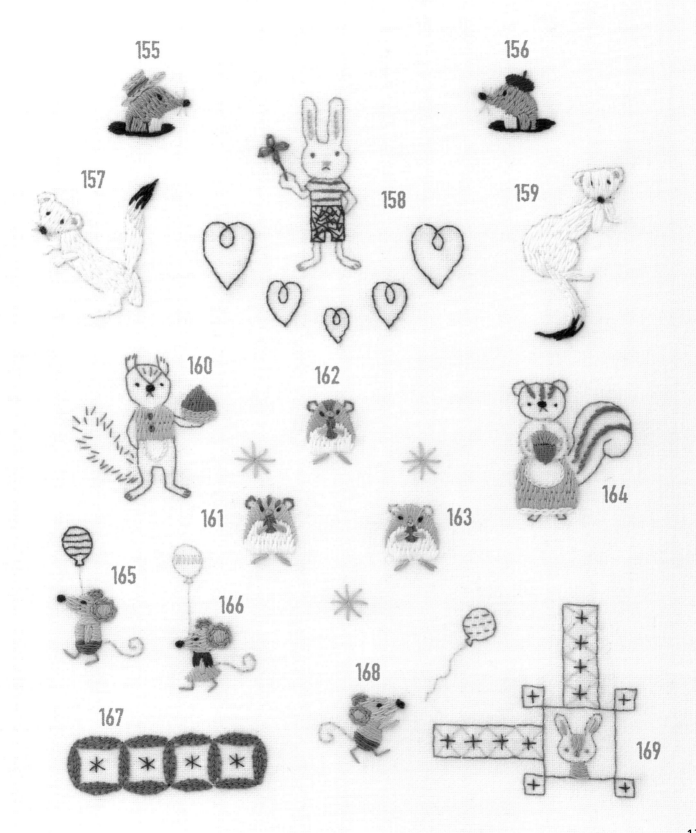

155

156

157

158

159

160

161

162

163

164

165

166

167

168

169

Zodiac Animals

Instructions: pages 80–81
Design & Embroidery: Sayuri Horiuchi

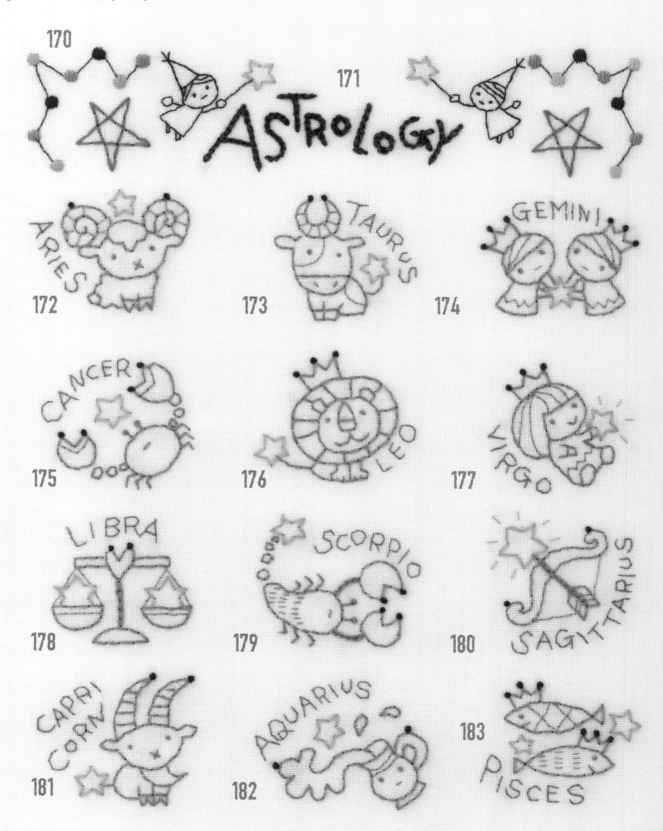

170

171

172 ARIES

173 TAURUS

174 GEMINI

175 CANCER

176 LEO

177 VIRGO

178 LIBRA

179 SCORPIO

180 SAGITTARIUS

181 CAPRICORN

182 AQUARIUS

183 PISCES

Animal Friends

Instructions: pages 82–83
Design & Embroidery: Sayuri Horiuchi

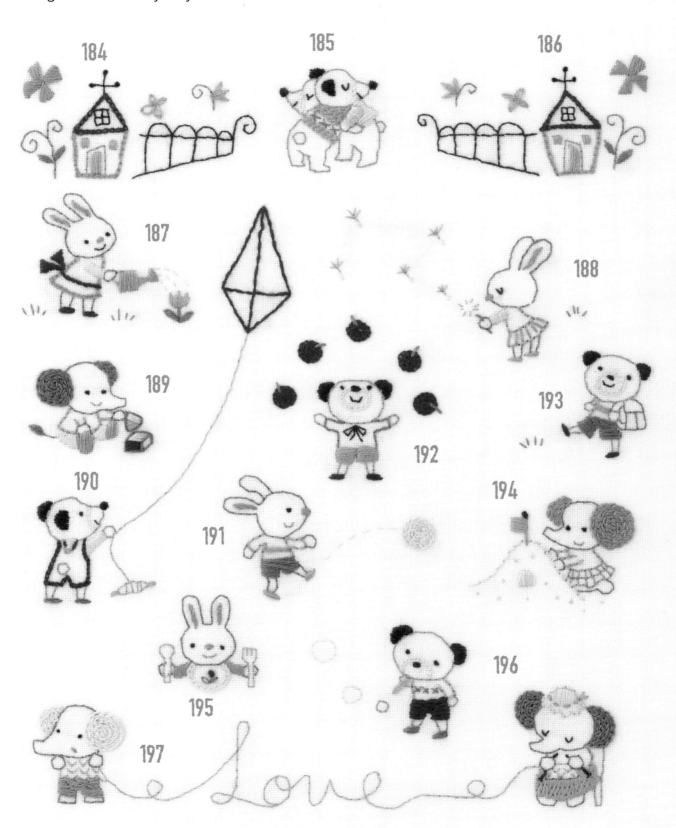

Storybook Animals

Instructions: pages 84–87
Design & Embroidery: siesta (Fumiko Saito)

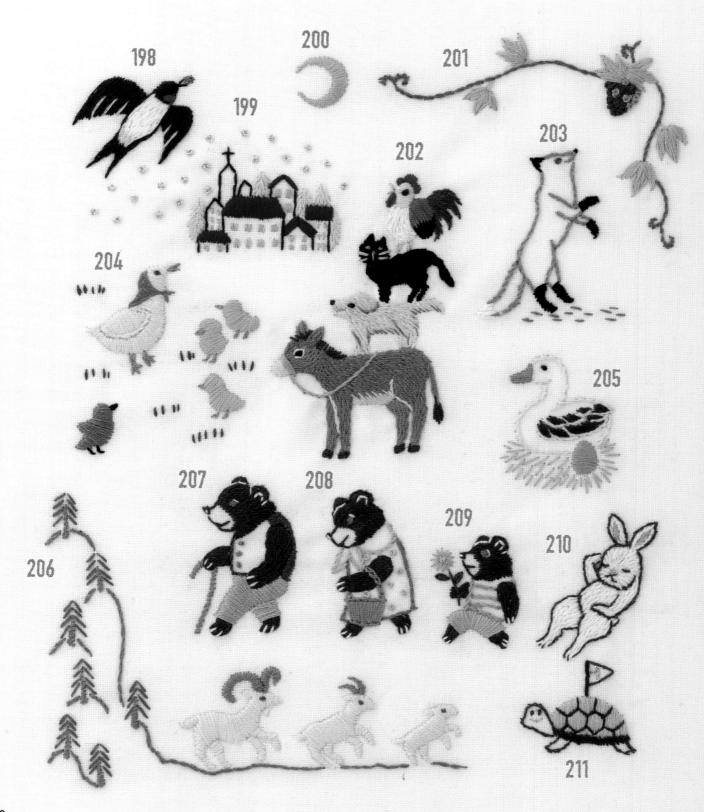

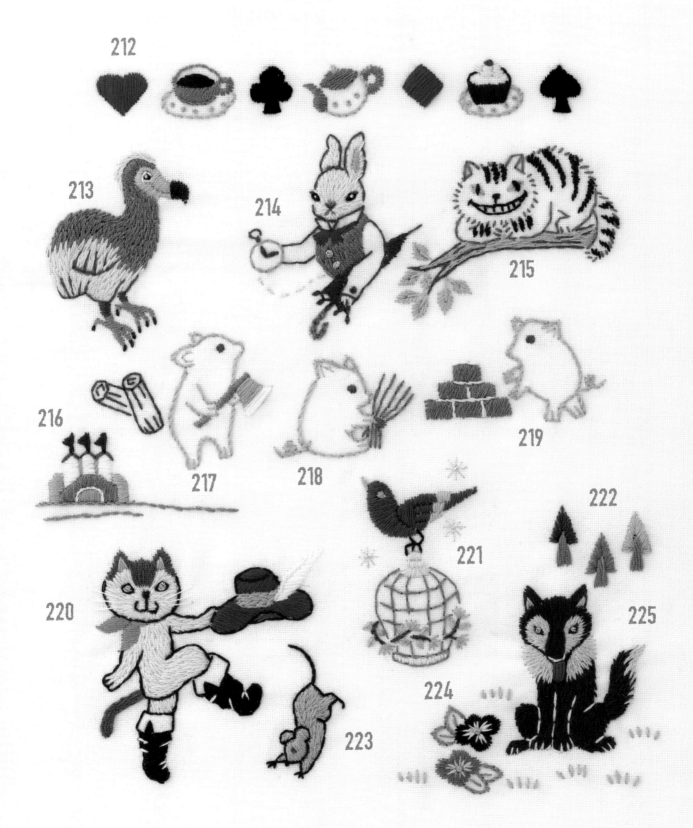

212

213

214

215

216

217

218

219

220

221

222

223

224

225

Folk Animals

Instructions: pages 88–91
Design & Embroidery: Nitka

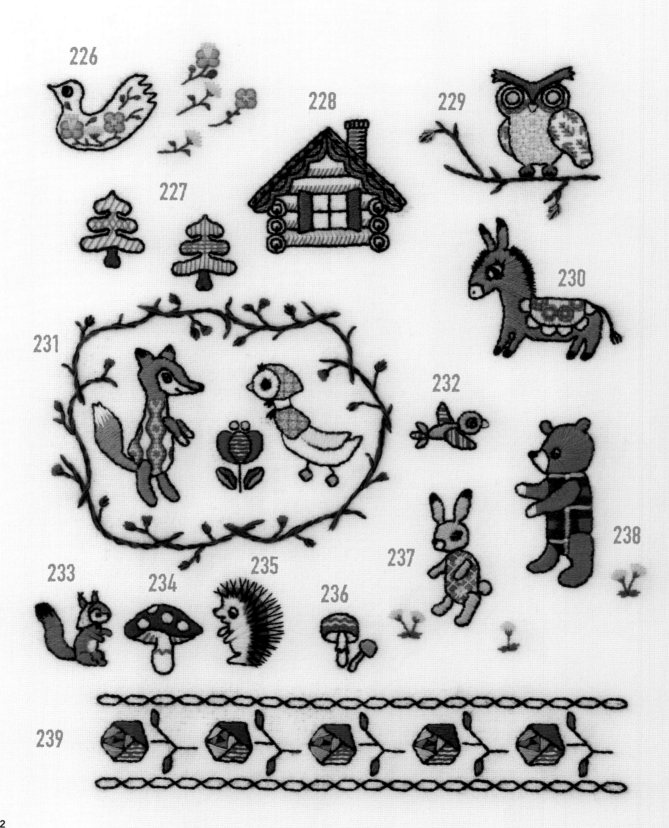

226

227

228

229

230

231

232

233

234

235

236

237

238

239

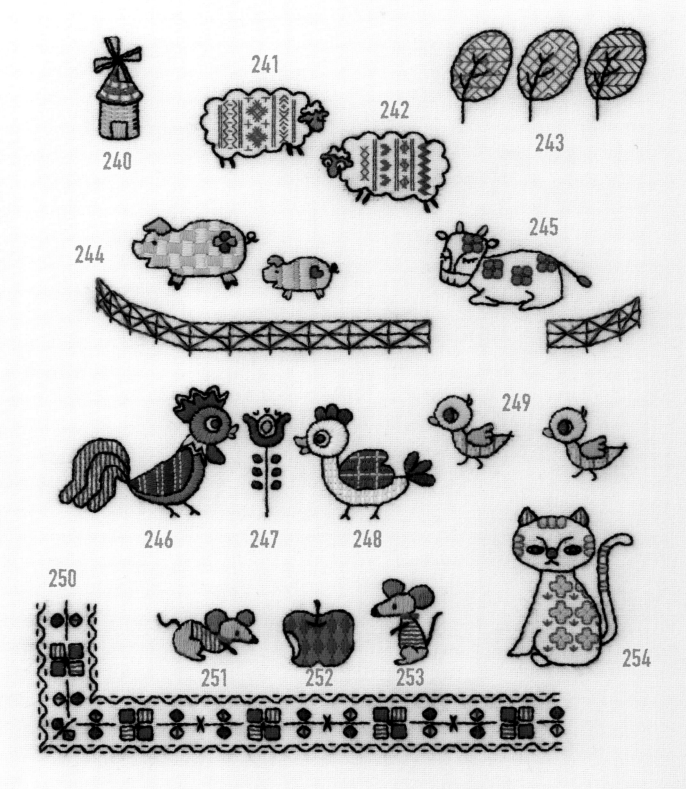

240

241

242

243

244

245

246

247

248

249

250

251

252

253

254

Beautiful Birds

Instructions: pages 92–95
Design & Embroidery: Tomoko Watanabe

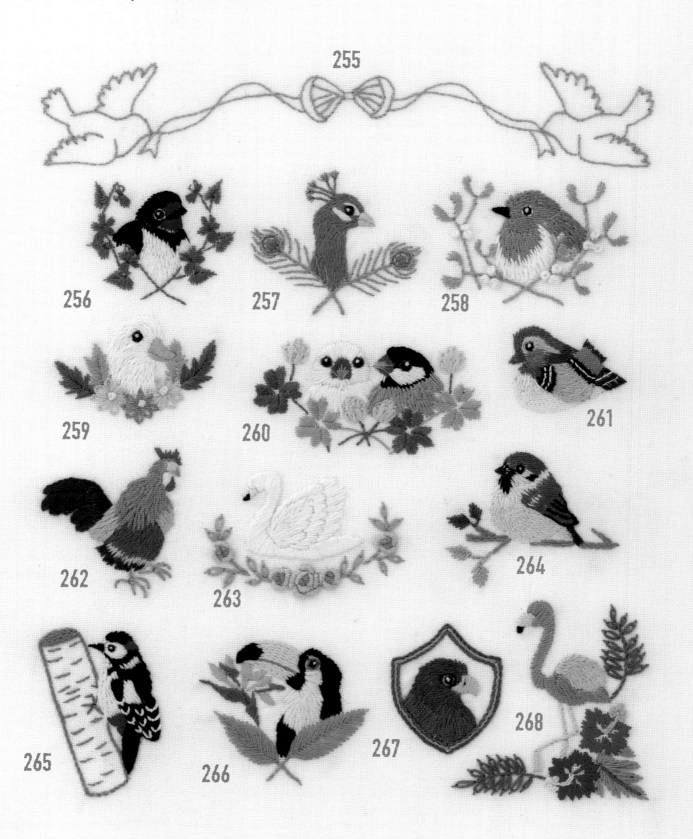

255

256

257

258

259

260

261

262

263

264

265

266

267

268

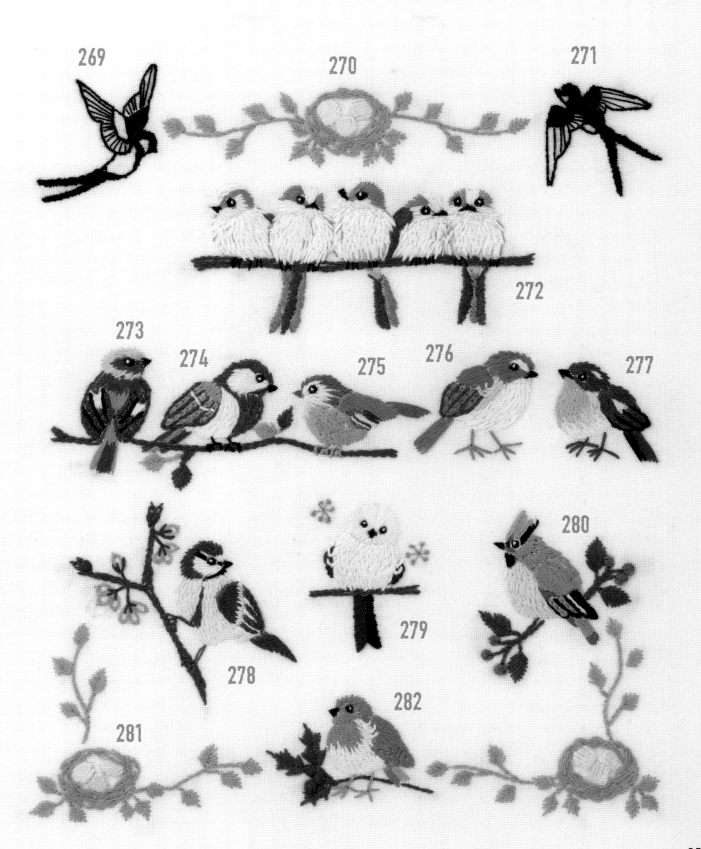

269

270

271

272

273

274

275

276

277

278

279

280

281

282

Pretty Parakeets

Instructions: pages 96–97
Design & Embroidery: Tomoko Watanabe

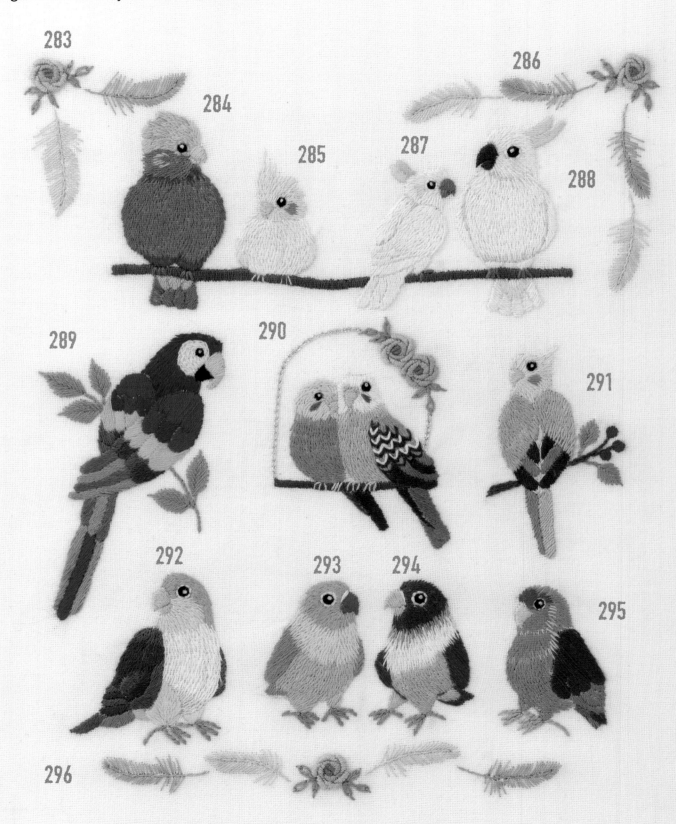

Stylish Animals

Instructions: pages 98–99
Design & Embroidery: Tomoko Watanabe

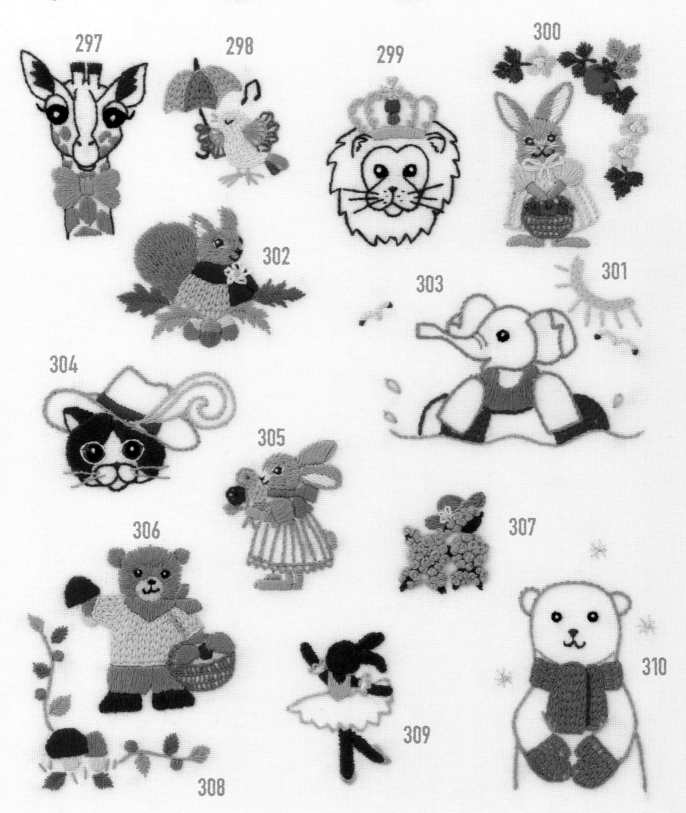

297

298

299

300

302

303

301

304

305

306

307

309

310

308

Dashing Dogs

Instructions: pages 100–103
Design & Embroidery: Pocorute Pocochiru

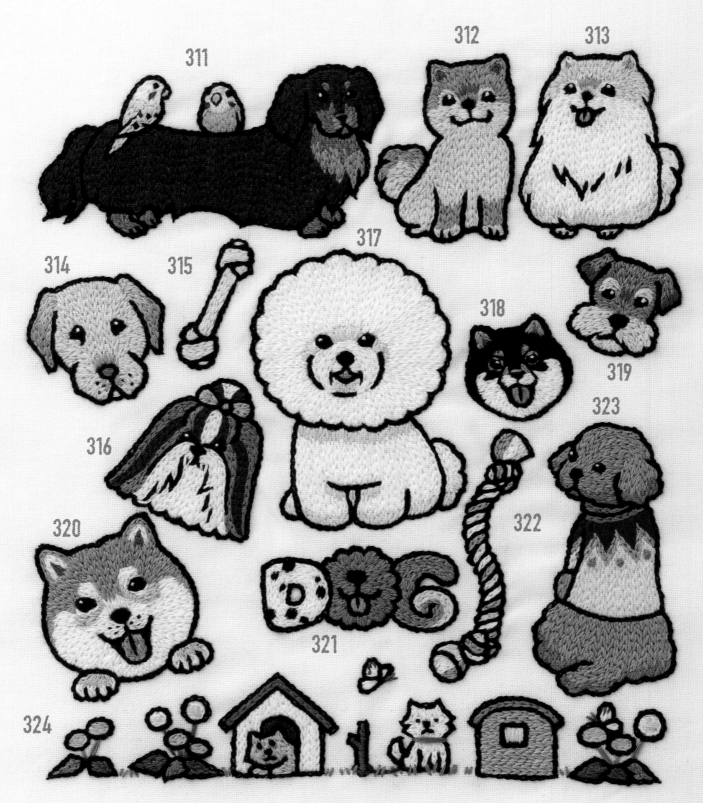

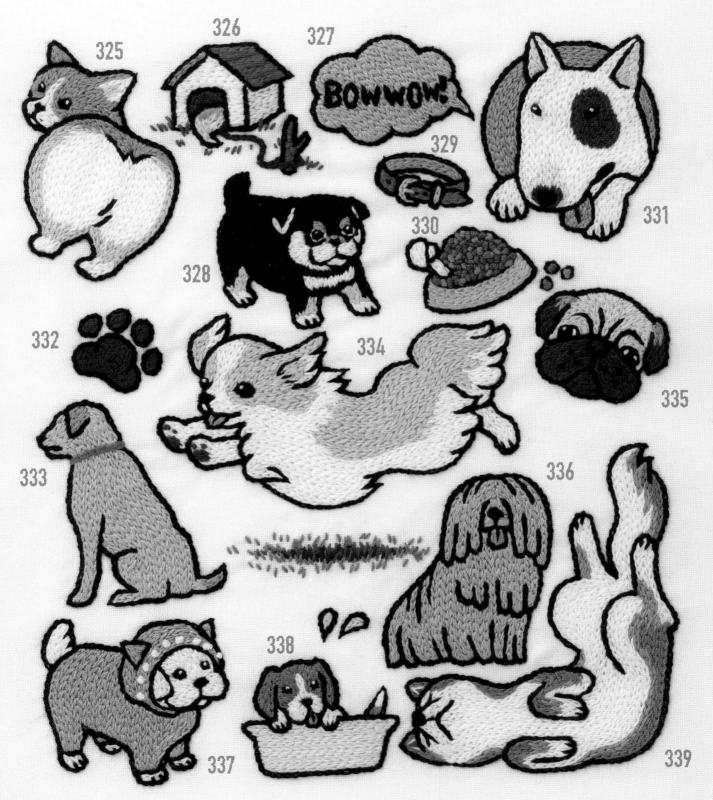

Curious Cats

Instructions: pages 104–107
Design & Embroidery: Pocorute Pocochiru

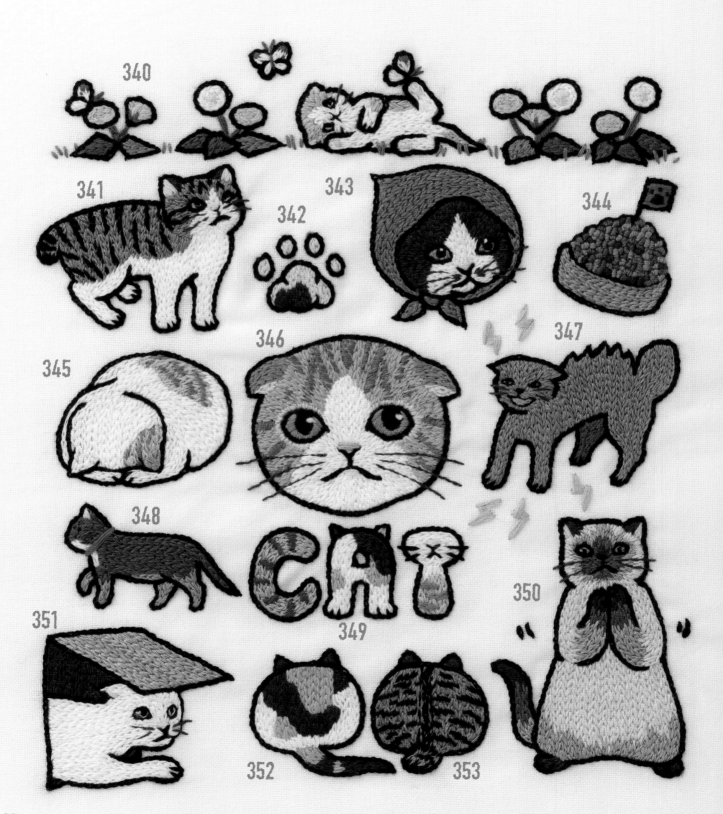

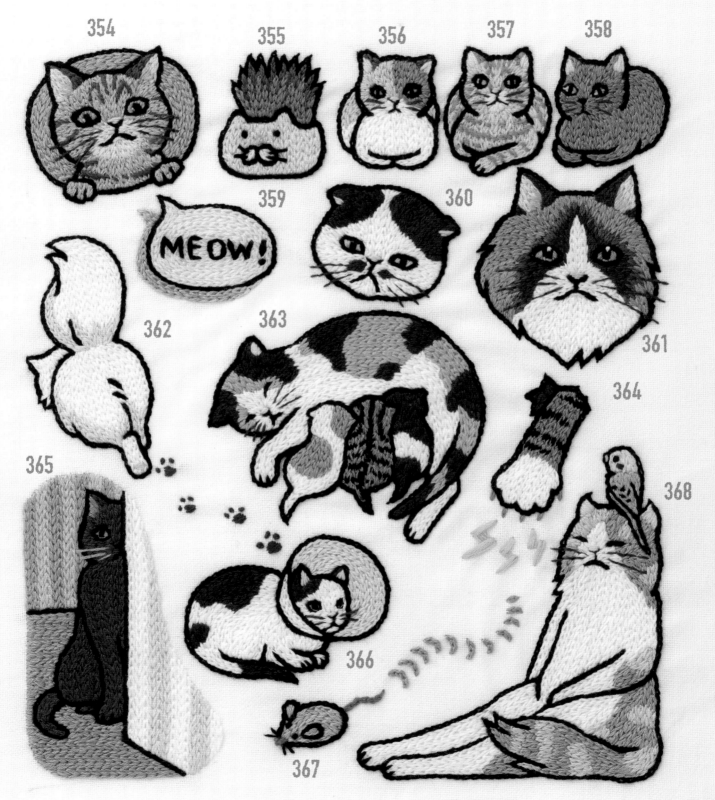

Animal Emblems

Instructions: pages 108–109
Design: annas
Embroidery: Miyuki Saito

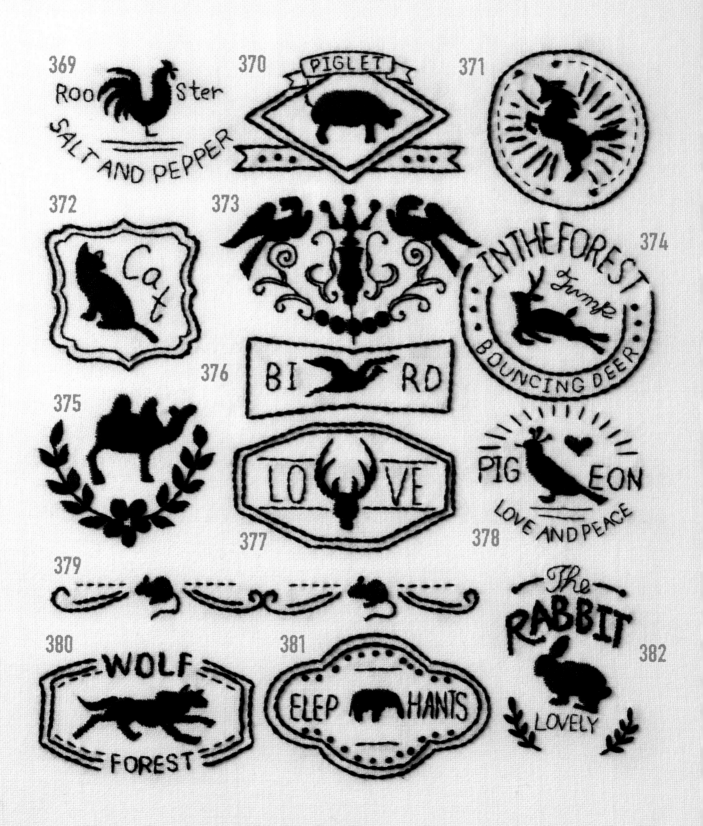

At the Circus

Instructions: pages 110–111
Design: annas
Embroidery: Miyuki Saito

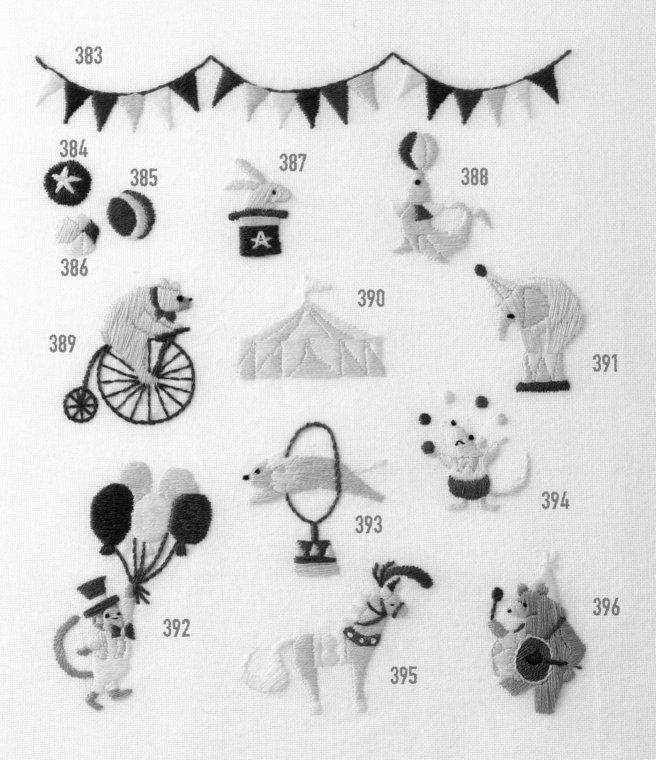

Animal Alphabets

Instructions: pages 112–115
Design & Embroidery: Noriko Komurata

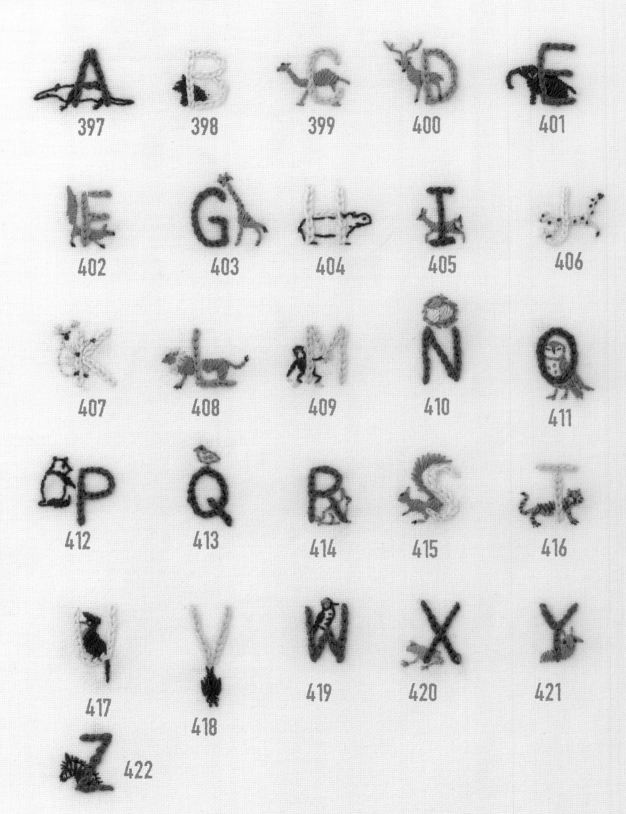

397 398 399 400 401

402 403 404 405 406

407 408 409 410 411

412 413 414 415 416

417 418 419 420 421

422

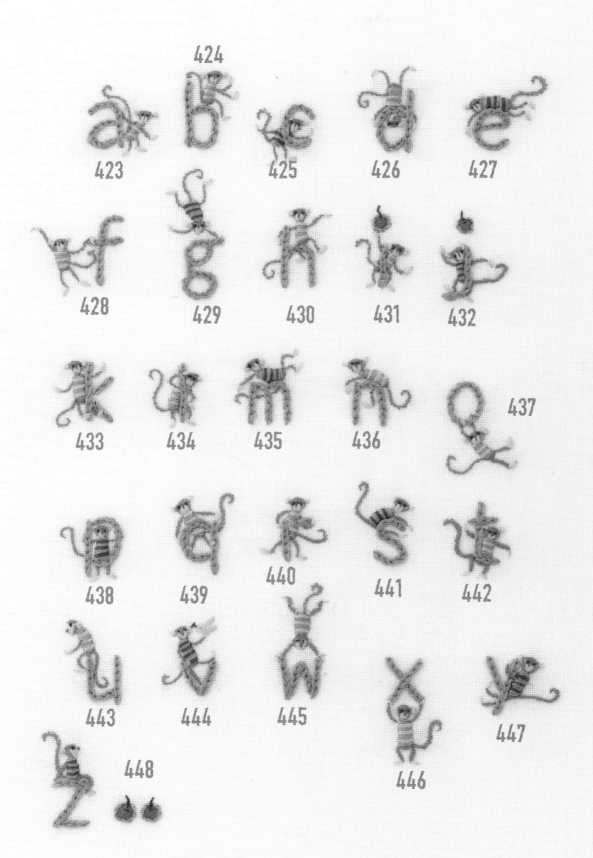

424

423

425

426

427

428

429

430

431

432

433

434

435

436

437

438

439

440

441

442

443

444

445

446

447

448

35

Animal Alphabets

Instructions: pages 116–119
Design & Embroidery: Shigeko Kawakami

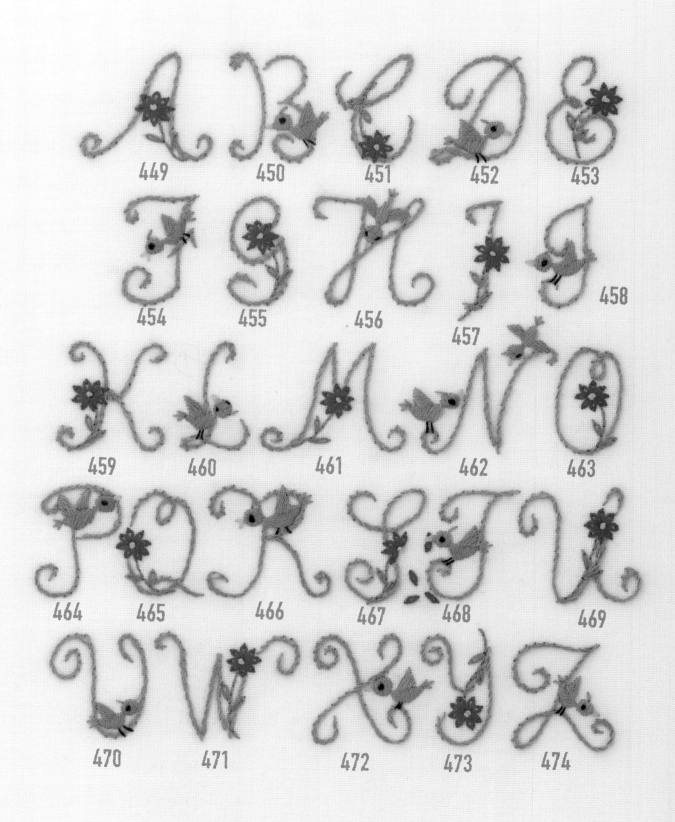

449 450 451 452 453

454 455 456 457 458

459 460 461 462 463

464 465 466 467 468 469

470 471 472 473 474

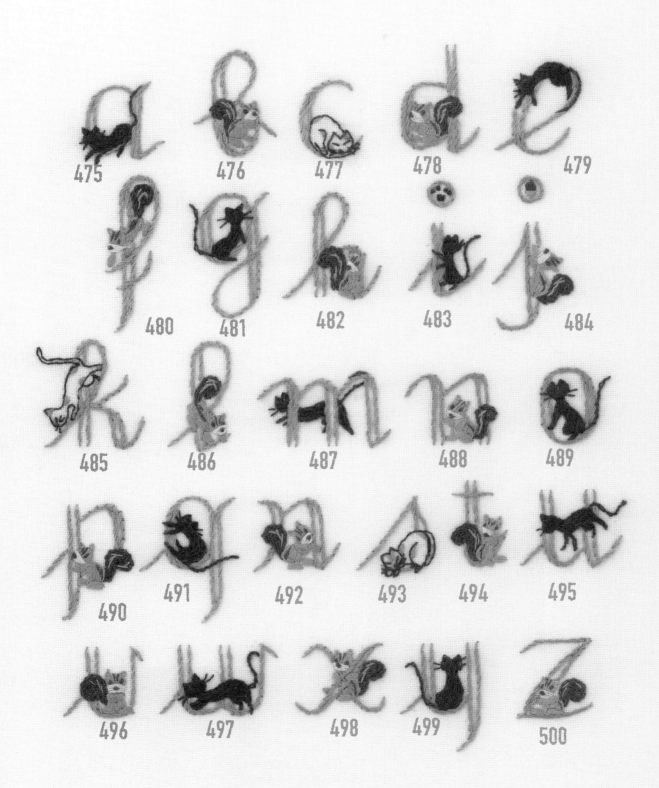

475 476 477 478 479

480 481 482 483 484

485 486 487 488 489

490 491 492 493 494 495

496 497 498 499 500

PROJECT INSPIRATION GALLERY

The designs in this book can be stitched on a variety of everyday items, from scarves and hats to bags and table linens. These cute animal motifs are sure to add cheer wherever they're stitched, so grab a needle and thread!

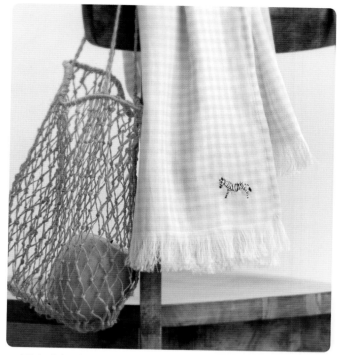

This black and white zebra adds a whimsical touch to a simple scarf.

Motif 26 on page 58

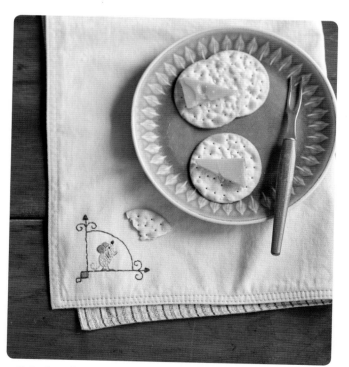

Stitch a fun little mouse on the corner of your placemats and napkins to make your guests smile!

Motif 150 on page 76

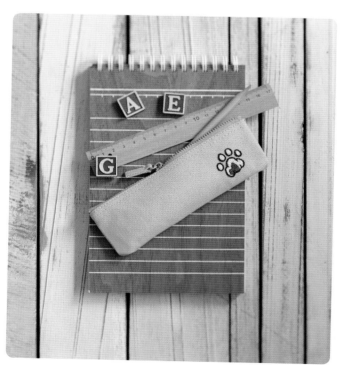

Are you a cat lover? Add a pawprint motif to a zippered pouch.

Motif 342 on page 104

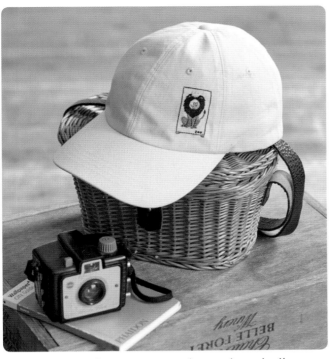

Stitch your favorite animal on a baseball cap
for one-of-a-kind style.

Motif 36 on page 60

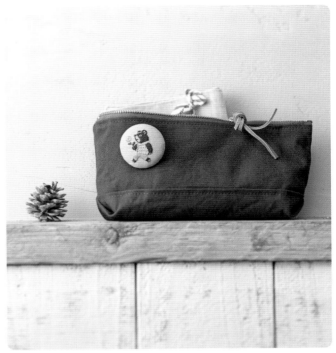

Try stitching a small motif onto a brooch,
then pin it onto your favorite bag or pouch.

Motif 209 on page 84

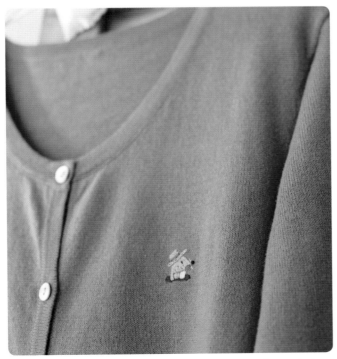

Add an animal motif to the chest of a solid
cardigan or polo shirt for a classic look.

Motif 155 on page 78

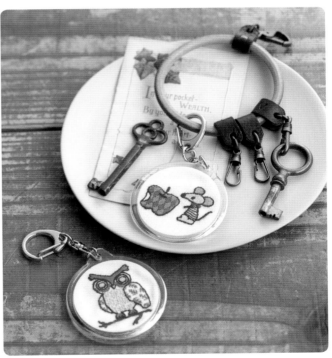

Make your own keychains featuring
cute and colorful motifs.

Motifs 229, 252, and 253 on pages 88–90

TOOLS & MATERIALS

EMBROIDERY FLOSS -

All of the designs in this book were created with No. 25 embroidery floss. This type of floss is composed of six strands that can be easily separated, allowing you to adjust the thickness. Olympus brand floss was used to stitch the designs in this book. A conversion chart for DMC brand is included on page 55.

No. 25 embroidery floss

Each skein of floss includes a label with a three- or four-digit color number. Metallic embroidery floss colors include an S before the color number. These numbers are used to represent the required floss color in the stitch diagram for each design.

Metallic embroidery floss

NEEDLES -

Use embroidery needles, which feature large eyes designed to accommodate embroidery floss. French embroidery needles are popular for their sharp tips that travel through a variety of fabrics with ease. Embroidery needles are available in several sizes, but sizes 3–7 should work for the designs in this book. Use the proper size needle based on the number of strands.

Remember, the higher the needle size, the smaller the needle!

French embroidery needles

Needle Size	Number of Strands
No. 3	6
No. 5	3–4
No. 7	1–2

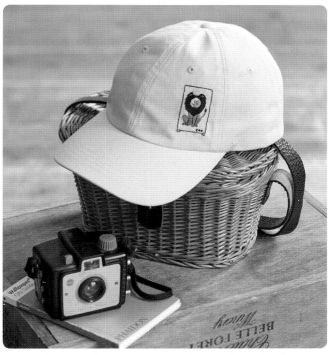

Stitch your favorite animal on a baseball cap
for one-of-a-kind style.

Motif 36 on page 60

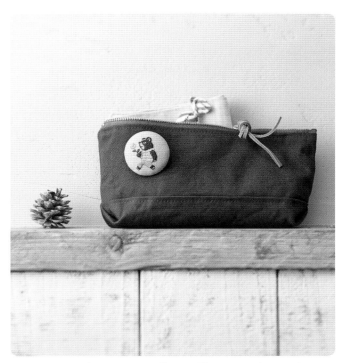

Try stitching a small motif onto a brooch,
then pin it onto your favorite bag or pouch.

Motif 209 on page 84

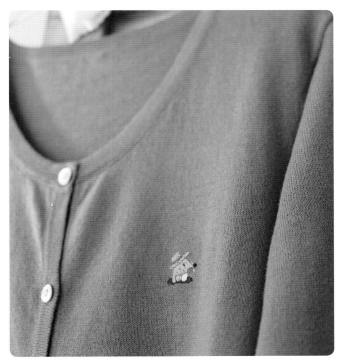

Add an animal motif to the chest of a solid
cardigan or polo shirt for a classic look.

Motif 155 on page 78

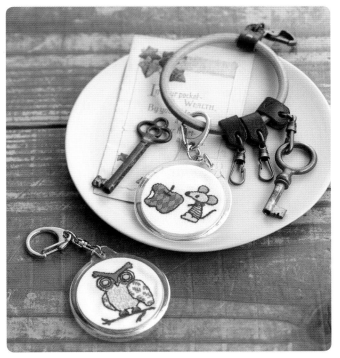

Make your own keychains featuring
cute and colorful motifs.

Motifs 229, 252, and 253 on pages 88–90

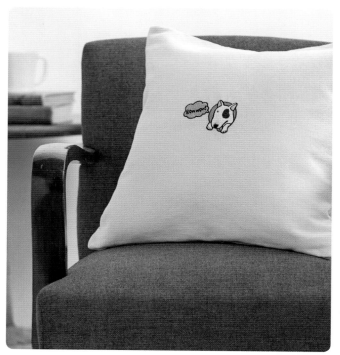

Add a dose of color and personality to your home with embroidered throw pillows.

Motifs 327 and 331 on page 102

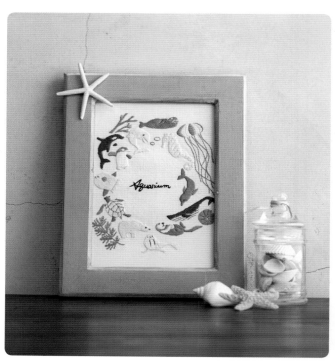

Stitch up one of the larger scenes to make an animal-inspired sampler.

Motifs 57-73 on page 64

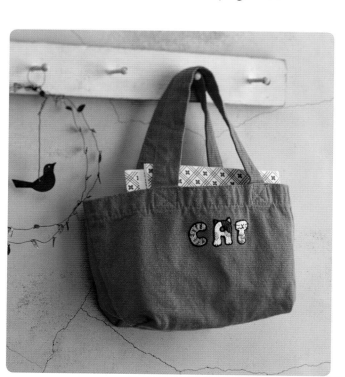

Give a simple tote bag a stylish makeover with a few embroidery stitches.

Motif 349 on page 104

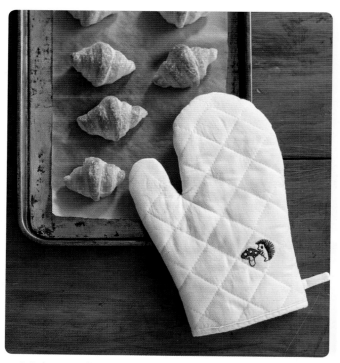

Make cooking more fun by adding this cute hedgehog and mushroom vignette to an oven mitt.

Motifs 234 and 235 on page 88

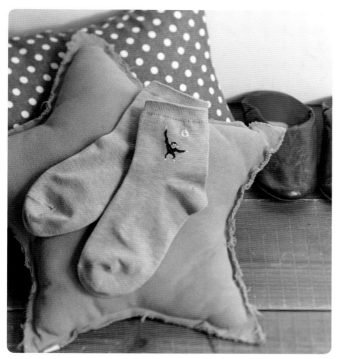

Personalize your socks with a
fun monkey motif.

Motif 2 on page 56

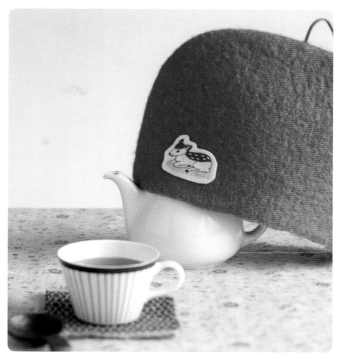

These motifs can be stitched onto felt
to create animal patches, perfect for
embellishing clothing and accessories.

Motif 97 on page 68

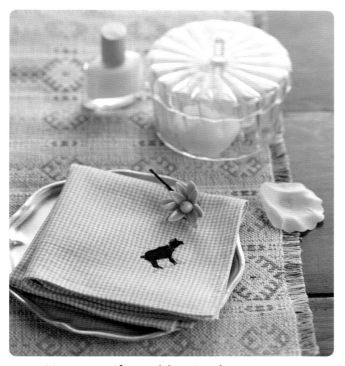

Use a motif to add a simple accent to
the corner of a handkerchief.

Motif 117 on page 72

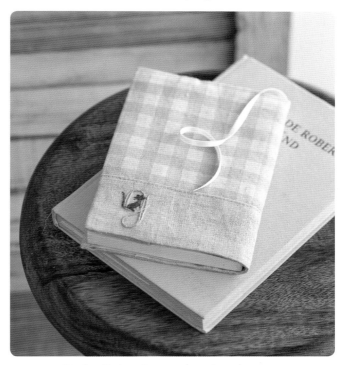

Embellish a journal or bookcover
with your initial.

Motif 481 on page 118

TOOLS & MATERIALS

EMBROIDERY FLOSS -

All of the designs in this book were created with No. 25 embroidery floss. This type of floss is composed of six strands that can be easily separated, allowing you to adjust the thickness. Olympus brand floss was used to stitch the designs in this book. A conversion chart for DMC brand is included on page 55.

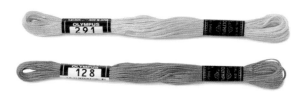

No. 25 embroidery floss

Each skein of floss includes a label with a three- or four-digit color number. Metallic embroidery floss colors include an S before the color number. These numbers are used to represent the required floss color in the stitch diagram for each design.

Metallic embroidery floss

NEEDLES -

Use embroidery needles, which feature large eyes designed to accommodate embroidery floss. French embroidery needles are popular for their sharp tips that travel through a variety of fabrics with ease. Embroidery needles are available in several sizes, but sizes 3–7 should work for the designs in this book. Use the proper size needle based on the number of strands.

Remember, the higher the needle size, the smaller the needle!

Size 3
Size 5
Size 7

French embroidery needles

Needle Size	Number of Strands
No. 3	6
No. 5	3–4
No. 7	1–2

SCISSORS -

Use small thread snips to cut embroidery floss and fabric shears to cut embroidery fabric. Remember, sharp scissors make the job easier!

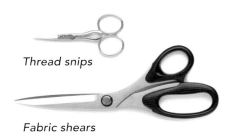

Thread snips

Fabric shears

FABRICS & HOOPS -

You can embroider just about any type of fabric, including cotton, linen, felt, and wool. For best results, look for a plain-woven fabric designed especially for embroidery.

Use an embroidery hoop to hold your fabric taut while stitching and prevent it from puckering. A 4–6 in (10–15 cm) hoop will work for most of the designs in this book.

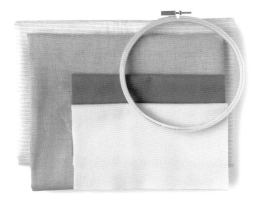

GETTING STARTED

HOW TO TRANSFER THE DESIGNS -

1. Position dressmaker's carbon paper on your embroidery fabric with the chalk side down.

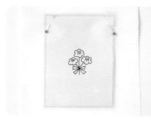

2. Copy the motif onto tracing paper. Align the tracing paper on top of the dressmaker's carbon paper. Position an acetate sheet on top.

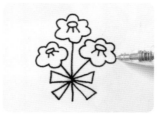

3. Trace the motif using a stylus or ballpoint pen.

The acetate sheet isn't absolutely necessary, but it protects the tracing paper and makes the tracing process smoother.

4. The pressure of the pen will transfer the chalk onto the embroidery fabric in the outline of the motif.

HOW TO PREPARE EMBROIDERY FLOSS -

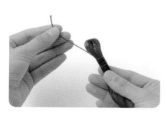

1. Hold the skein of embroidery floss with the label positioned between your fingers. Slowly pull one end.

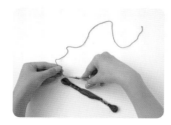

2. Cut a 16–20 in (40–50 cm) long piece.

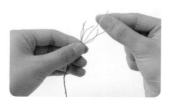

3. Separate the individual strands.

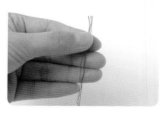

4. Realign the number of strands needed to stitch the design. Always separate the strands, even when using all six strands, as this practice prevents the thread from knotting.

HOW TO THREAD THE NEEDLE -

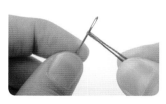 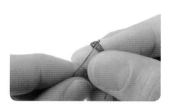 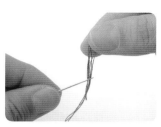 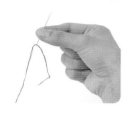

1. Make a fold about 1 in (2.5 cm) from the end of the floss. Use your needle to apply pressure and create a crease.

2. Insert the fold through the eye of the needle.

3. Pull the folded end through the eye of the needle.

4. Position the needle about 4 in (10 cm) from the crease.

HOW TO MAKE KNOTS -

TO START STITCHING

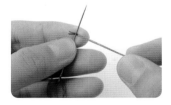 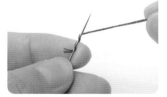 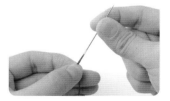

1. Align the needle and the end of the floss.

2. Wrap the floss around the needle once or twice.

3. Hold the wraps between your fingers and pull the needle out. Move the wraps to the end of the floss to create a knot.

4. The knot is complete.

TO FINISH STITCHING

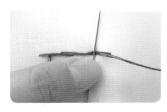 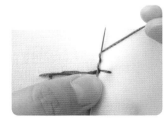 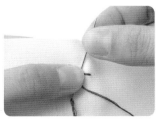

1. Align the needle on top of the stitches on the wrong side of the embroidery fabric.

2. Wrap the floss around the needle once or twice.

3. Use your finger to hold the wraps against the fabric and pull the needle out.

4. The knot is complete.

RIGHT SIDE VS WRONG SIDE -

The wrong side of your embroidery is just as important as the right side because it can influence the finished appearance of your work. Always start and finish your threads as shown on the previous page in order to produce neat, professional-looking finished designs.

When starting a new area of stitching, start a new thread or pass the needle under the back of other stitches to move to the new area, even if you're using the same color floss. This way, you'll avoid having long threads visible on the right side of your work. This is especially important when you're embroidering on light fabric.

The following photos show finished motifs as they appear on both the right and wrong sides.

Right Side *Wrong Side*

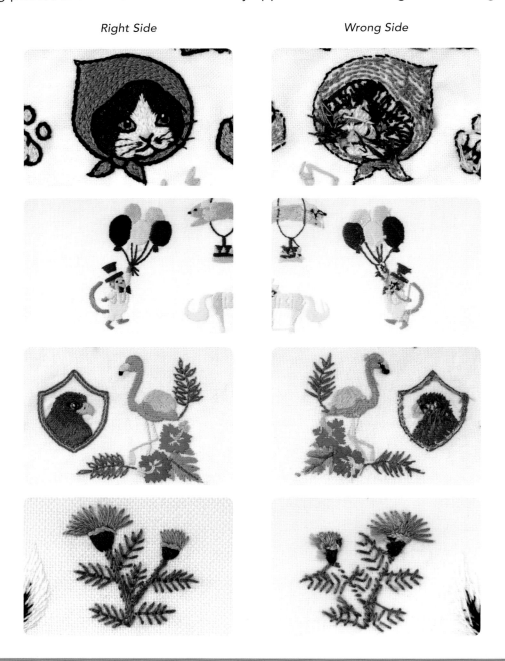

EMBROIDERY FLOSS ---

Since No. 25 embroidery floss is composed of six strands, you can separate the strands to adjust the thickness of your stitching. The following guide shows the different results that can be achieved by stitching with different numbers of strands.

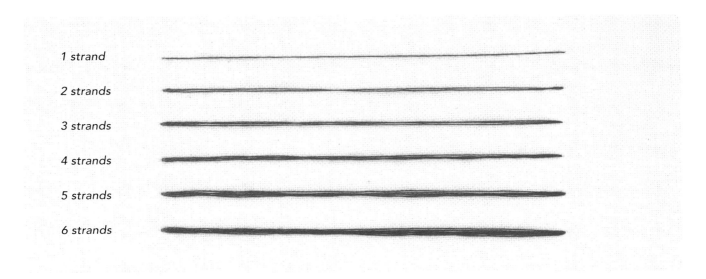

Altering the number of strands will influence the finished look of your stitches. The following examples show the different results than can be achieved by altering the number of strands of embroidery floss.

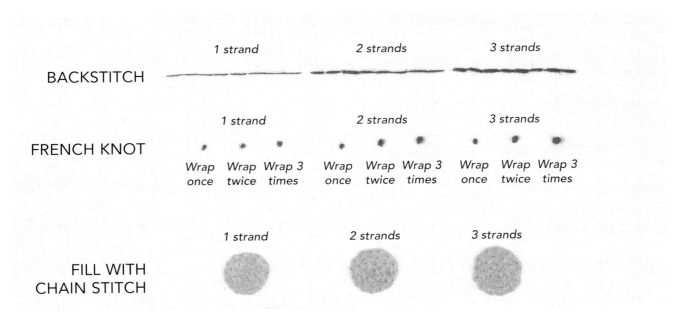

EMBROIDERY STITCH GUIDE

All of the designs in this book were made with 15 basic embroidery stitches. The following guide illustrates how to make each stitch.

▶ STRAIGHT STITCH

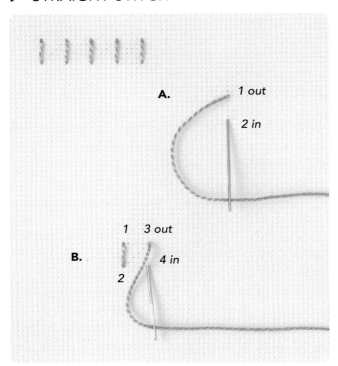

▶ RUNNING STITCH

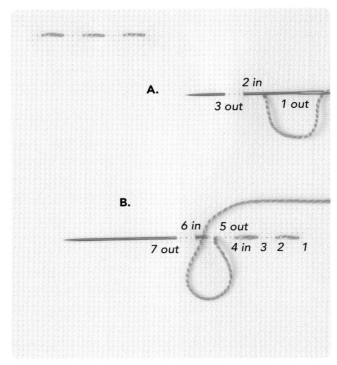

A. Draw the needle out at 1 and insert at 2. One straight stitch is complete.

B. To make the next stitch, draw the needle out at 3 and insert at 4.

A. Draw the needle out at 1. Insert at 2 and draw it out again at 3 in one movement.

B. Continue making a couple of stitches at a time.

▶ BACKSTITCH

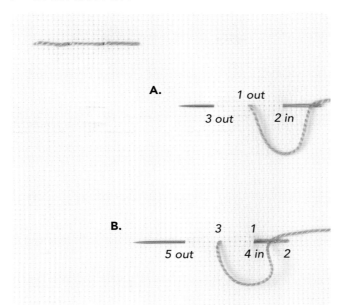

A. Draw the needle out at 1. Insert at 2, which is one stitch length behind 1. Draw the needle out again at 3, which is one stitch length ahead of 1.

B. To make the next stitch, insert the needle at 4, which is actually the same hole as 1. Draw the needle out again at 5, which is one stitch length ahead of 3.

▶ OUTLINE STITCH

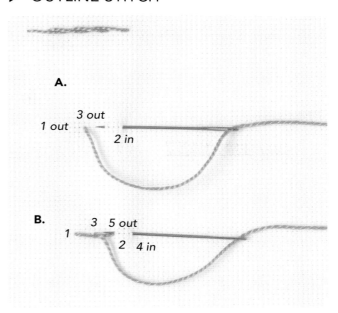

This stitch is worked from left to right.

A. Draw the needle out at 1. Insert the needle one stitch length away at 2, then draw the needle out again at 3, which is halfway between 1 and 2.

B. To make the next stitch, insert the needle one stitch length away at 4. Draw the needle out again at 5, which is halfway between 3 and 4.

▶ CHAIN STITCH

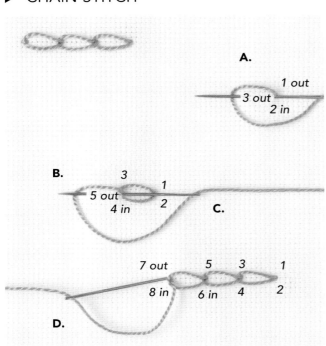

A. Draw the needle out at 1. Wrap the floss around the needle tip. Insert the needle at 2 (this is actually the same hole as 1), then draw the needle out again at 3.

B. Pull the needle and floss through the fabric until a small loop remains. The first chain is now complete. Insert the needle back through the same hole at 4.

C. Use the same process to draw the needle tip out at 5 and complete the next chain.

D. To finish a row of chain stitches, insert the needle back through the fabric, making a tiny straight stitch to secure the final chain, as shown by 8.

▶ FRENCH KNOT

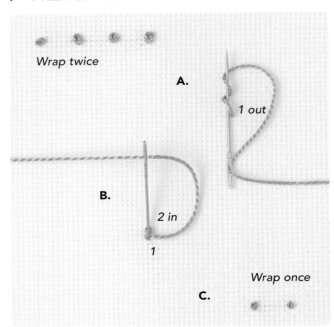

A. Draw the needle out at 1. Wrap the thread around the needle tip twice.

B. Insert the needle back through the fabric at 2, just next to 1. Hold the wraps against the fabric as you pull the needle and thread through the fabric to complete the knot.

C. For smaller French knots, wrap the thread around the needle only once.

▶ LAZY DAISY STITCH

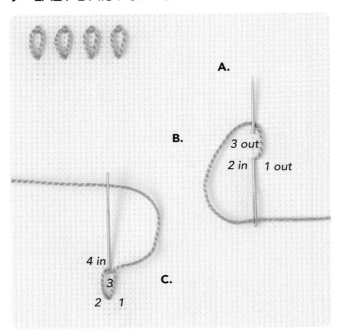

A. Draw the needle out at 1. Wrap the floss around the needle tip. Insert the needle at 2 (this is actually the same hole as 1), then draw the needle out again at 3.

B. This is the same process used to make a chain stitch as shown on page 49.

C. Pull the needle and floss through the fabric until a small loop remains. Insert the needle at 4, making a tiny straight stitch to secure the loop.

▶ SATIN STITCH

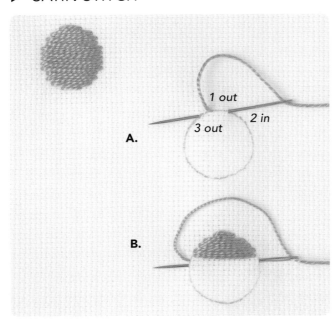

A. Draw the needle out at 1, insert it at 2, then draw the needle out again at 3.

B. Continue stitching from outline to outline to fill the area.

▶ LONG AND SHORT STITCH

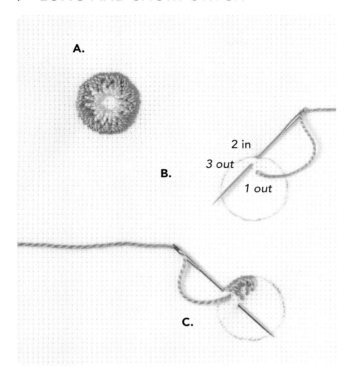

▶ CROSS STITCH

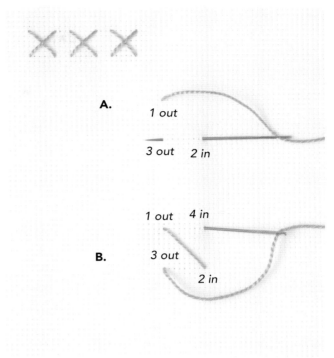

A. Draw the needle out at 1. Insert the needle at 2, then draw the needle out again at 3.

B. The distance from 2 to 3 should be shorter than the distance from 1 to 2.

C. Continue making both long and short stitches to fill the area.

It doesn't matter whether you cross the stitches from top to bottom or bottom to top, just be consistent throughout your work.

A. Draw the needle out at 1. Make a diagonal stitch and insert the needle at 2. Draw the needle out again at 3, which is parallel to 2.

B. Make another diagonal stitch to complete the cross and insert the needle at 4, which is parallel to 1.

▶ FISHBONE STITCH

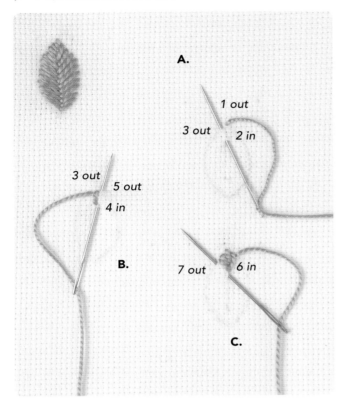

A. Draw the needle out at 1, which is at the tip of the design. Insert the needle at 2 in the center of the design. Draw the needle out at 3 along the left edge of the design.

B. Next, insert the needle at 4, which is adjacent to 2. Draw the needle out at 5 along the right edge of the design.

C. Insert the needle at 6, just beneath 4 and 5. Draw the needle out at 7. Continue working diagonal stitches from the center of the design.

▶ BULLION KNOT

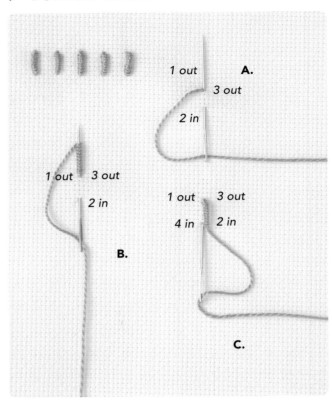

A. Draw the needle out at 1 (this will be the top of the knot). Insert the needle at 2, then draw the needle out again at 3, which is actually the same hole as 1.

B. Wrap the floss around the tip of the needle as many times as directed. Hold the wraps against the fabric as you pull the needle out.

C. Insert the needle at 4, which is actually the same hole as 2, to secure the knot against the fabric.

▶ FLY STITCH

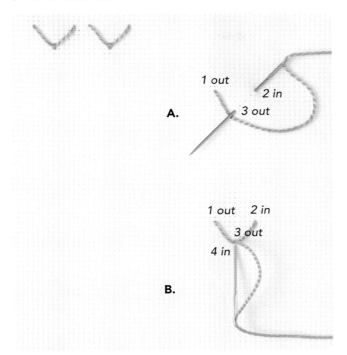

A. Draw the needle out at 1. Arrange the floss at a downward diagonal angle, then insert the needle at 2, which is parallel to 1. Draw the needle out at 3.

B. Pull the floss through the fabric to form a V-shaped stitch. Insert the needle at 4, directly beneath 3, to make a tiny straight stitch and secure the V in place.

▶ BLANKET STITCH

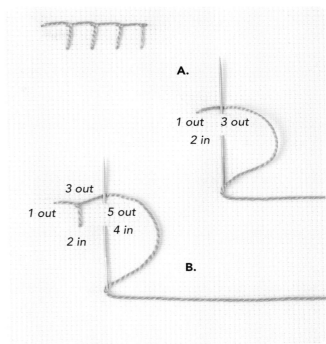

A. Draw the needle out at 1. Arrange the floss so it extends to the right. Insert the needle at 2, then draw it out at 3, which is parallel to 1. Take care to keep the floss under the needle.

B. To make the next stitch, arrange the floss so it extends to the right, then insert the needle at 4, which is parallel to 2. Draw the needle out at 5, which is parallel to 1 and 3, taking care to keep the floss under the needle.

▶ COUCHING STITCH

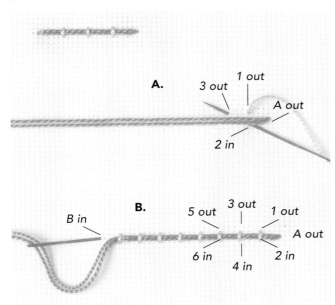

This example uses two different colors of floss to illustrate how to work the couching stitch. Refer to individual motif instructions for floss colors.

A. Draw the main floss color out at A, then arrange along the motif line. Draw the secondary floss color out at 1. Insert at 2, directly below 1, making a tiny straight stitch to secure the main floss in place. Draw the needle out at 3.

B. Continue making tiny, equally spaced straight stitches to secure the main floss in place along the motif line. To finish stitching, insert the main floss color back through the fabric at B.

HOW TO USE THIS BOOK

Each motif in this book comes with a stitch guide, which includes all the information you'll need to stitch up the design, as well as a full-size template that can be traced easily. At the top of each page, you'll also find some general information that applies to all the motifs included on that page. The following guide explains how to read the embroidery diagrams.

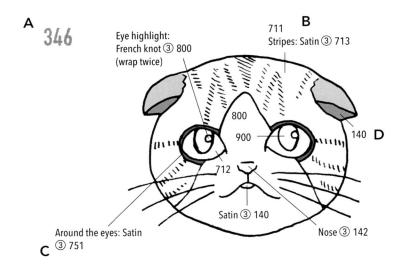

A. Motif Number: Use the motif number to locate your design. These numbers are also included on the photos of the stitched motifs at the beginning of the book.

B. Stitch Name: These labels indicate which stitch to use for each element of the design. Note: The word "stitch" is omitted from these labels in order to save space. Refer to the Embroidery Stitch Guide on pages 48–53 for instructions on making each of the 15 basic stitches used in this book.

C. Number of Strands: The circled numbers (for example: ②) indicate how many strands of embroidery floss to use when making a stitch.

D. Color Number: These numbers indicate the required floss color. Olympus brand floss was used to stitch the designs in this book. A conversion chart for DMC brand is included on page 55.

THREAD CONVERSION CHART --

OLYMPUS	DMC	OLYMPUS	DMC	OLYMPUS	DMC	OLYMPUS	DMC	OLYMPUS	DMC
119	3354	290	11	487	315	721	677	845	611
121	3687	291	727	488	413	722	676	900	310
127	602	293	370	501	726	731	712	1027	347
140	754	303	518	502	725	733	742	1028	815
141	353	304	518	503	977	734	842	1035	347
142	352	306	824	512	783	735	422	1051	947
143	351	307	824	516	782	736	435	1083	892
144	350	312	927	520	745	737	433	1120	335
145	349	314	926	521	743	738	801	1121	309
156	891	316	924	524	740	739	938	1122	326
163	224	331	775	534	740	740	543	1602	316
165	223	341	927	535	971	741	842	1702	758
175	900	342	926	541	3078	742	842	1705	347
188	304	343	924	544	973	743	841	1706	347
190	326	353	334	555	741	744	840	1906	3685
194	815	354	826	561	831	745	839	1908	3685
198	902	355	311	562	3046	751	945	2012	470
204	501	358	823	563	3045	754	970	2013	469
205	520	364	799	564	831	755	921	2014	937
210	471	365	798	565	830	758	920	2016	935
212	471	366	797	575	400	765	225	2020	3819
214	470	370	827	580	728	768	356	2021	907
216	470	372A	995	581	973	778	838	2039	828
218	469	384	807	583	972	784	922	2040	598
220	959	386	517	600	554	786	920	2041	598
221	993	392	806	602	553	791	225	2042	597
222	992	393	517	603	552	792	225	2052	3363
229	703	411	3024	604	552	793	316	2070	3348
232	700	413	647	616	29	794	316	2072	3850
237	460	414	646	625	208	796	221	2445	320
243	369	415	645	626	208	800	B5200	3041	168
245	367	416	535	631	3743	810	762	3042	415
246	501	421	3024	632	3042	811	3024	3043	930
251	504	432	647	640	809	812	648	3715A	995
253	368	440	3041	643	161	813	3022	5205	727
257	319	441	317	644	798	814	3023	7010	3774
262	954	451	453	653	208	815	611	7020	3866
274	3347	453	451	655	550	825	801	7025	3857
275	3346	483	415	711	402	841	822	S101	E316
276	3346	484	415	712	921	842	613	S105	E168
277	895	485	318	713	975	843	612	S106	E3821
283	833	486	414	714	300	844	611		

At the Zoo

Photos: page 6

■ ◯ = Number of strands (use 2 strands unless otherwise noted)
■ # = Color number
■ Outline stitch unless otherwise noted.

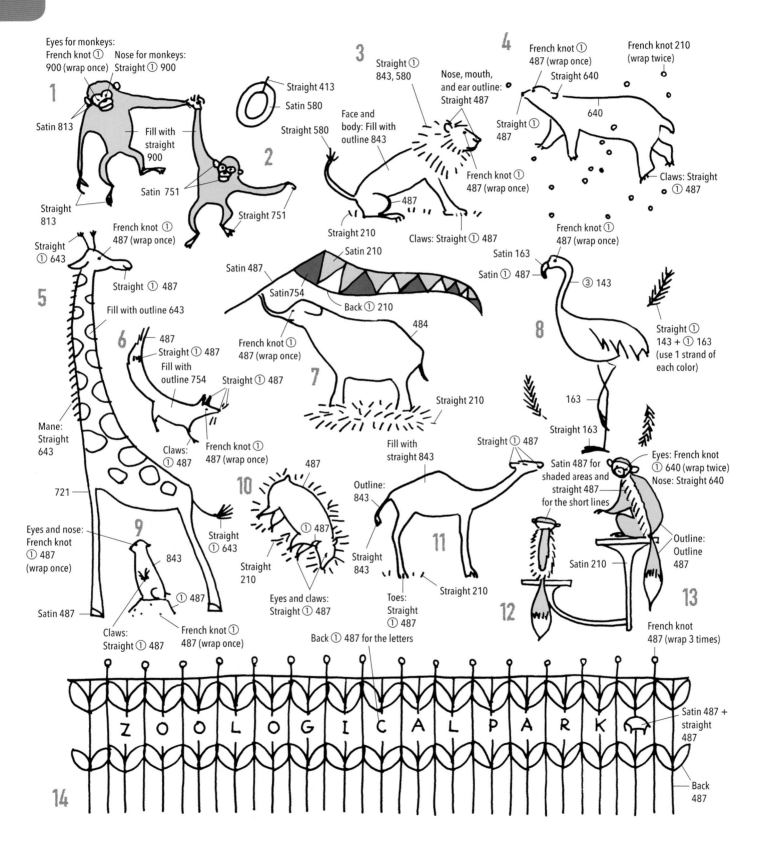

1
Eyes for monkeys: French knot ① 900 (wrap once)
Nose for monkeys: Straight ① 900
Satin 813
Fill with straight 900
Satin 751
Straight 813

2
Straight 413
Satin 580
Straight 580
Straight 751

3
Straight ① 843, 580
Nose, mouth, and ear outline: Straight 487
Face and body: Fill with outline 843
French knot ① 487 (wrap once)
Straight 210
487
Claws: Straight ① 487

4
French knot ① 487 (wrap once)
French knot 210 (wrap twice)
Straight 640
Straight ① 487
640
Claws: Straight ① 487
French knot ① 487 (wrap once)
Satin 163
Satin ① 487
③ 143

5
Straight ① 643
Straight ①
French knot ① 487 (wrap once)
Straight ① 487
Fill with outline 643
Mane: Straight 643
721

6
487
Straight ① 487
Fill with outline 754
Claws: Straight ① 487
French knot ① 487 (wrap once)
Straight ① 487

7
Satin 210
Satin 487
Satin 754
Back ① 210
484
French knot ① 487 (wrap once)
Straight 210

8
Straight ① 143 + ① 163 (use 1 strand of each color)
163
Straight 163

9
Eyes and nose: French knot ① 487 (wrap once)
Satin 487
843
① 487
Claws: Straight ① 487
French knot ① 487 (wrap once)

10
487
① 487
Straight 210
Eyes and claws: Straight ① 487

11
Fill with straight 843
Outline: 843
Straight ① 487
Straight 843
Toes: Straight ① 487
Straight 210
Back ① 487 for the letters

12
Satin 487 for shaded areas and straight 487 for the short lines
Satin 210

13
Eyes: French knot ① 640 (wrap twice)
Nose: Straight 640
Outline: Outline 487
French knot 487 (wrap 3 times)

Straight ① 643

14
ZOOLOGICAL PARK
Satin 487 + straight 487
Back 487

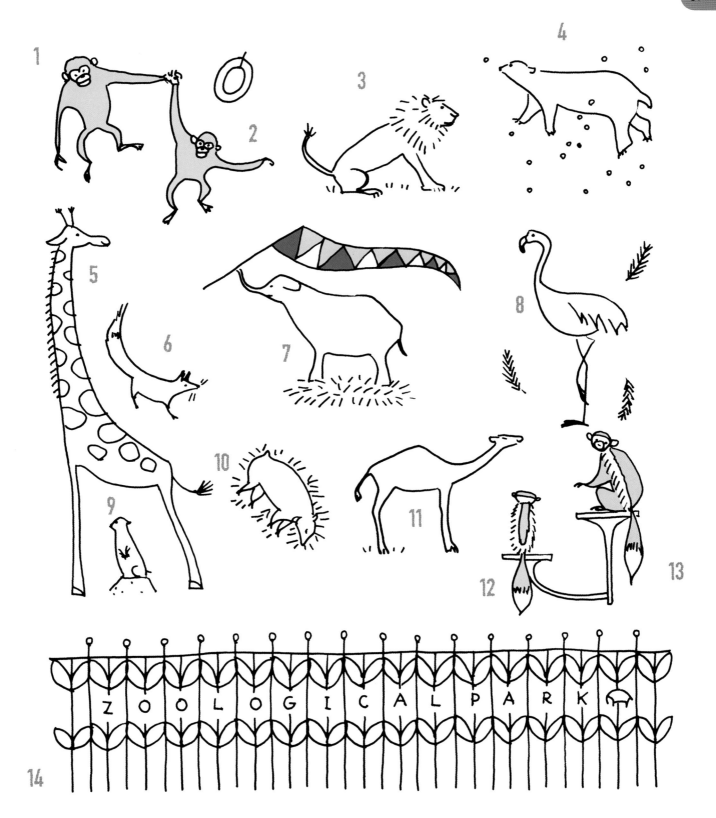

At the Zoo

Photos: page 7

- ■ ◯ = Number of strands (use 2 strands unless otherwise noted)
- ■ # = Color number
- ■ Outline stitch unless otherwise noted.

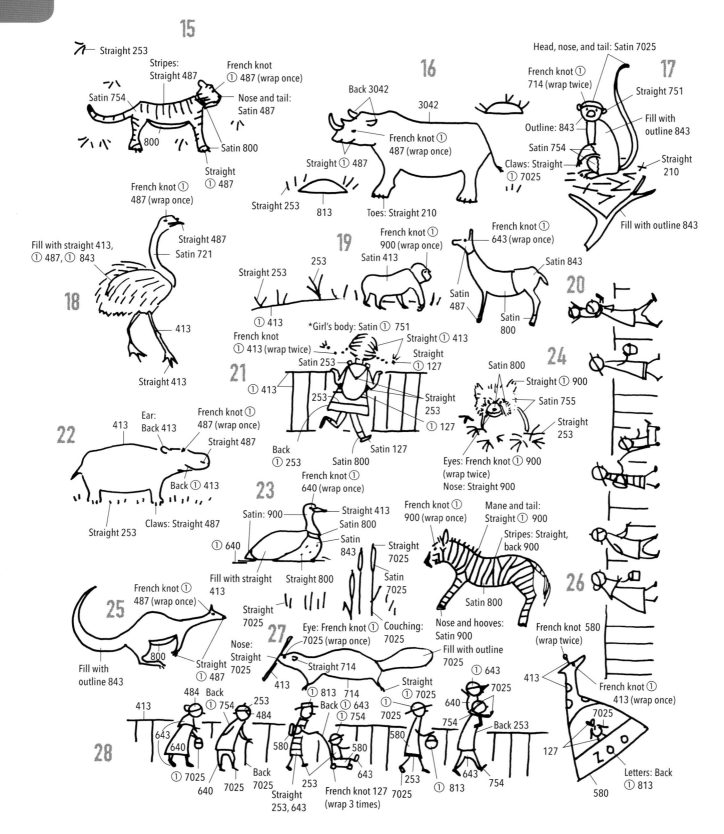

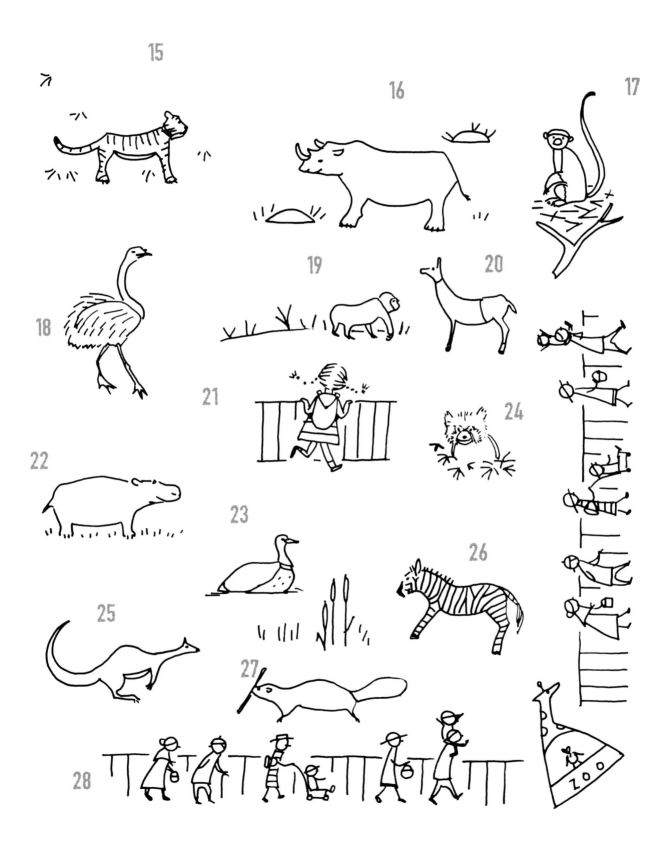

At the Zoo

Photos: page 8

■ ○ = Number of strands (use 2 strands unless otherwise noted)
■ # = Color number

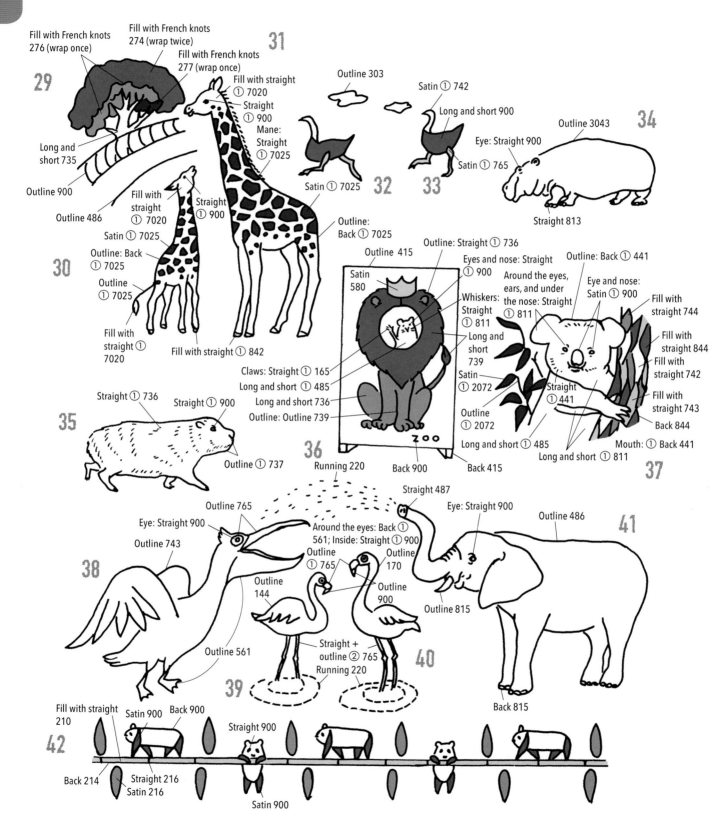

29 Fill with French knots 276 (wrap once)
Fill with French knots 274 (wrap twice)
Fill with French knots 277 (wrap once)
Long and short 735
Outline 900
Outline 486

31 Fill with straight ① 7020
Straight ① 900
Mane: Straight ① 7025

30 Fill with straight ① 7020
Straight ① 900
Satin ① 7025
Outline: Back ① 7025
Outline ① 7025
Fill with straight ① 7020
Fill with straight ① 842

Outline: Back ① 7025
Satin ① 7025

32 Outline 303
Satin ① 7025

33 Satin ① 742
Long and short 900
Satin ① 765

34 Eye: Straight 900
Outline 3043
Straight 813

35 Straight ① 736
Straight ① 900
Outline ① 737

36 Outline 415
Satin 580
Outline: Straight ① 736
Eyes and nose: Straight ① 900
Whiskers: Straight ① 811
Long and short 739
Satin ① 2072
Outline ① 2072
Long and short ① 485
Claws: Straight ① 165
Long and short ① 485
Long and short 736
Outline: Outline 739
Running 220
Back 900
Back 415

37 Outline: Back ① 441
Around the eyes, ears, and under the nose: Straight ① 811
Eye and nose: Satin ① 900
Fill with straight 744
Fill with straight 844
Fill with straight 742
Straight ① 441
Fill with straight 743
Back 844
Long and short ① 811
Mouth: ① Back 441

38 Outline 765
Eye: Straight 900
Outline 743
Outline 561
Around the eyes: Back ① 561; Inside: Straight ① 900
Outline ① 765
Outline 144

39 Outline 170
Outline 900
Straight + outline ② 765
Running 220

40

41 Straight 487
Eye: Straight 900
Outline 486
Outline 815
Back 815

42 Fill with straight 210
Satin 900
Back 900
Straight 900
Back 214
Straight 216
Satin 216
Satin 900

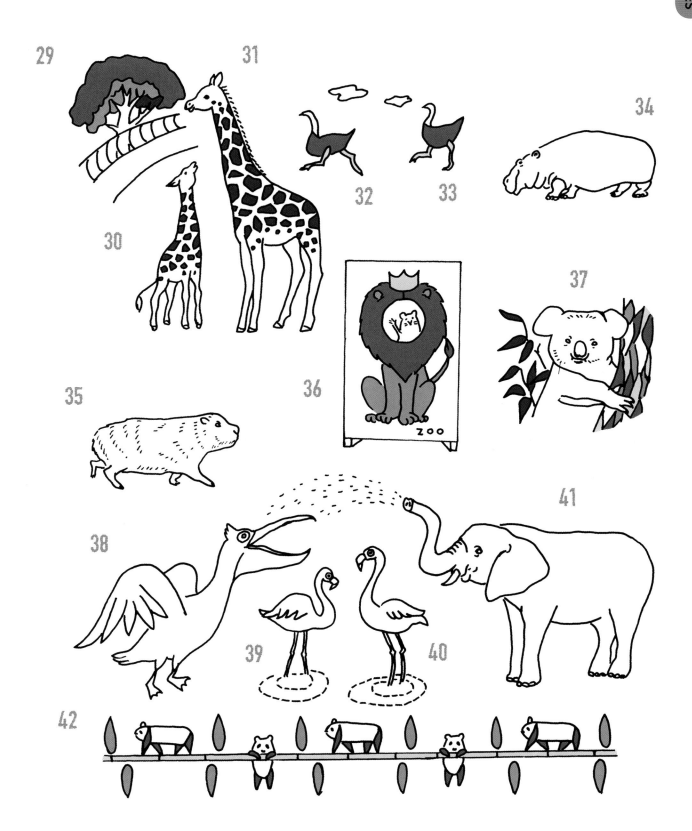

29

31

30

32

33

34

35

36

37

38

39

40

41

42

ZOO

At the Zoo

Photos: page 9

■ ◯ = Number of strands (use 2 strands unless otherwise noted)
■ # = Color number

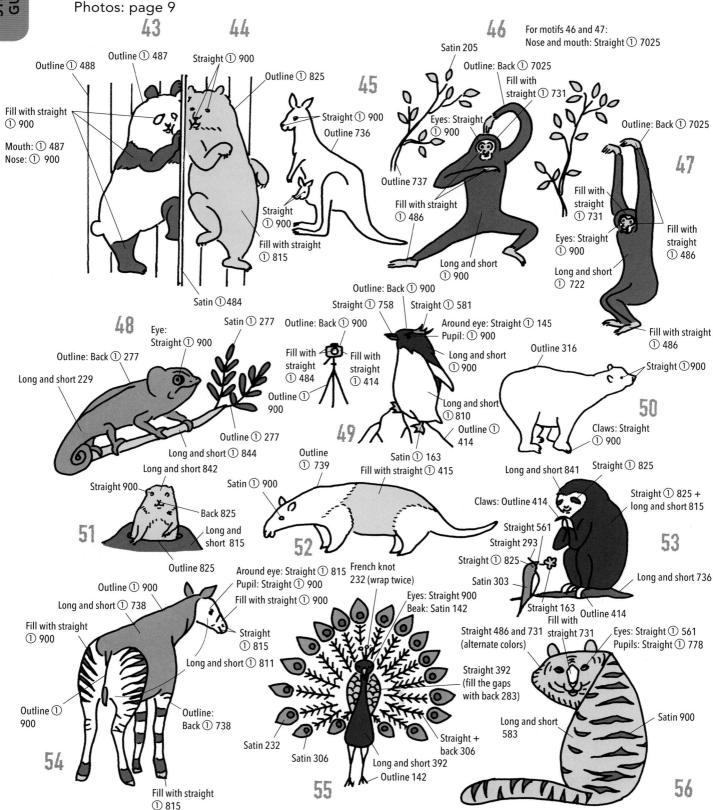

43
Outline ① 488
Outline ① 487
Fill with straight ① 900
Mouth: ① 487
Nose: ① 900

44
Straight ① 900
Outline ① 825
Satin ①484
Fill with straight ① 815

45
Straight ① 900
Outline 736
Straight ① 900

46
For motifs 46 and 47:
Nose and mouth: Straight ① 7025
Satin 205
Outline: Back ① 7025
Fill with straight ① 731
Eyes: Straight ① 900
Outline 737
Fill with straight ① 486
Long and short ① 900

47
Outline: Back ① 7025
Fill with straight ① 731
Eyes: Straight ① 900
Long and short ① 722
Fill with straight ① 486
Fill with straight ① 486

48
Eye: Straight ① 900
Satin ① 277
Outline: Back ① 277
Long and short 229
Outline ① 900
Long and short ① 844
Long and short 842

49
Outline: Back ① 900
Straight ① 758
Straight ① 581
Around eye: Straight ① 145
Pupil: ① 900
Fill with straight ① 484
Fill with straight ① 414
Outline ① 900
Long and short ① 900
Long and short ① 810
Outline ① 414
Satin ① 163
Fill with straight ① 415

50
Outline 316
Straight ①900
Claws: Straight ① 900

51
Straight 900
Back 825
Long and short 815
Outline 825

52
Outline ① 739
Satin ① 900

53
Long and short 841
Straight ① 825
Claws: Outline 414
Straight ① 825 + long and short 815
Straight 561
Straight 293
Straight ① 825
Satin 303
Straight 163
Outline 414
Fill with straight 731
Long and short 736

54
Outline ① 900
Long and short ① 738
Fill with straight ① 900
Around eye: Straight ① 815
Pupil: Straight ① 900
Fill with straight ① 900
Straight ① 815
Long and short ① 811
Outline ① 900
Outline: Back ① 738
Fill with straight ① 815

55
French knot 232 (wrap twice)
Eyes: Straight 900
Beak: Satin 142
Straight 486 and 731 (alternate colors)
Straight 392 (fill the gaps with back 283)
Straight + back 306
Satin 232
Satin 306
Long and short 392
Outline 142

56
Eyes: Straight ① 561
Pupils: Straight ① 778
Long and short 583
Satin 900

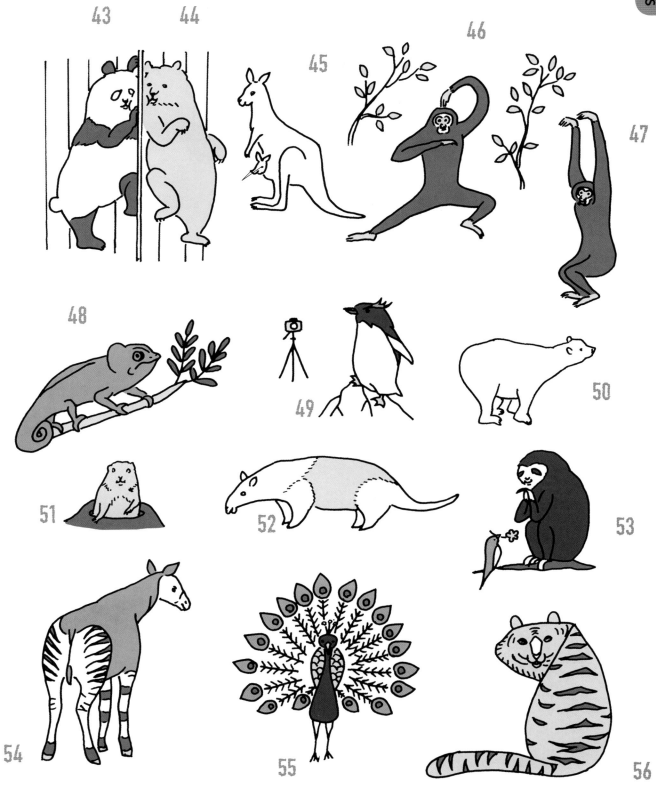

43 44

45

46

47

48

49

50

51

52

53

54

55

56

Visiting the Aquarium

Photos: page 10

- ■ ○ = Number of strands (use 2 strands unless otherwise noted)
- ■ # = Color number
- ■ Satin stitch unless otherwise noted.

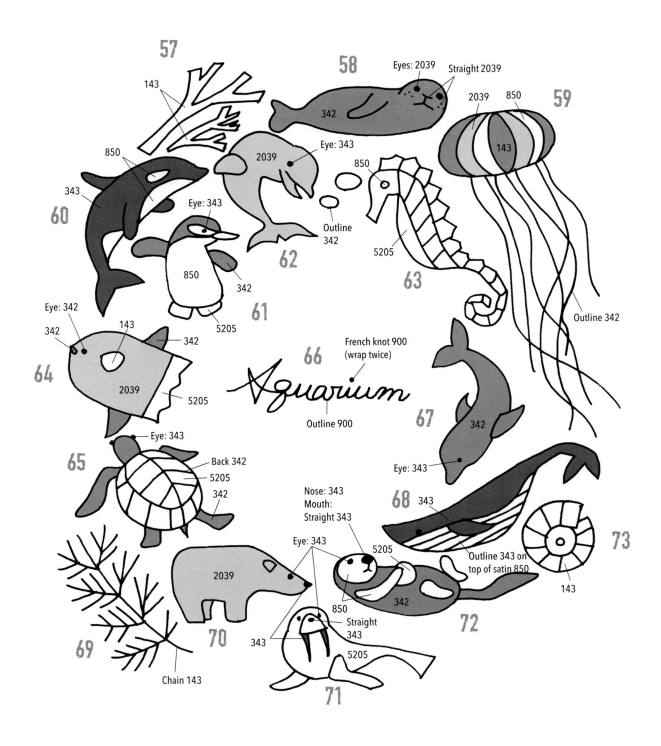

57

143

58 Eyes: 2039 Straight 2039

342

2039 850 59

143

850 Eye: 343

2039 850

60 343 Eye: 343 Outline 342 Outline 342

850 5205

Eye: 343 5205 63

850 342

61

Eye: 342 143 62

342 342

64 342

2039 66 French knot 900 (wrap twice)

5205 Aquarium 67

Outline 900 342

Eye: 343 Eye: 343

65 Back 342 68 343

5205 Nose: 343 5205 Outline 343 on top of satin 850

342 Mouth: Straight 343 73

Eye: 343

2039 850 143

Straight 343 342

69 70 343 72

Chain 143 5205 71

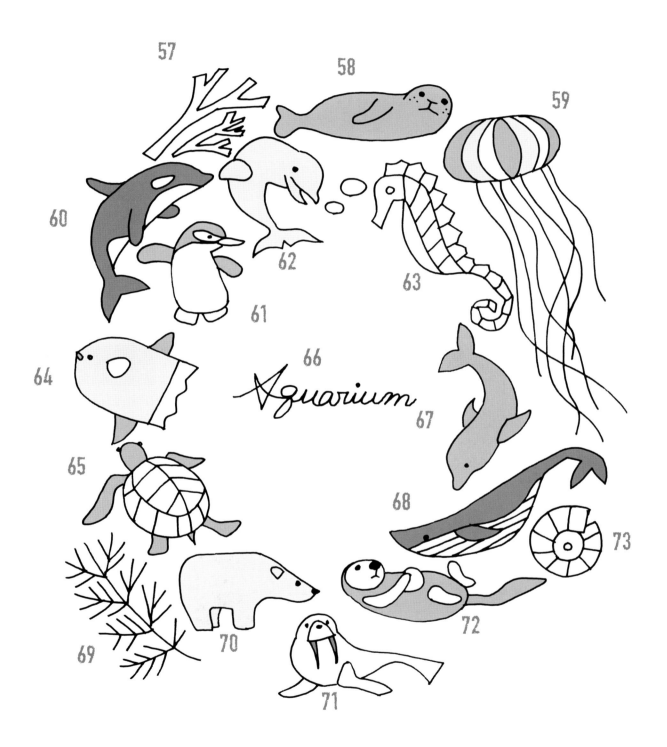

57
58
59
60
62
61
63
64
66
67
65
68
73
72
69
70
71

Aquarium

Mythological Creatures

Photos: page 11

■ ○ = Number of strands (use 2 strands unless otherwise noted)
■ # = Color number
■ Fill with satin stitch and use outline stitch for the lines unless otherwise noted.
■ French knot 343 (wrap twice) for the eyes unless otherwise noted.

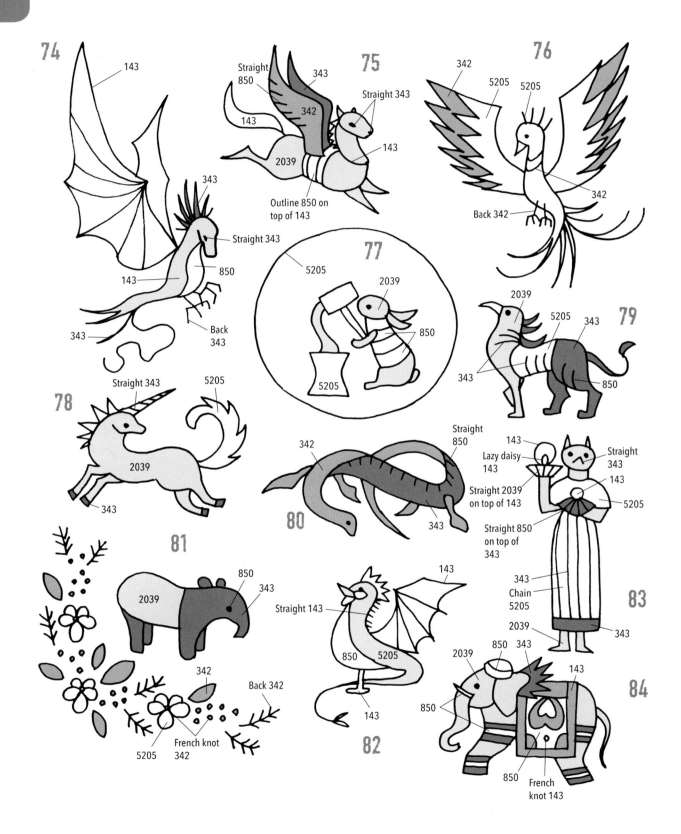

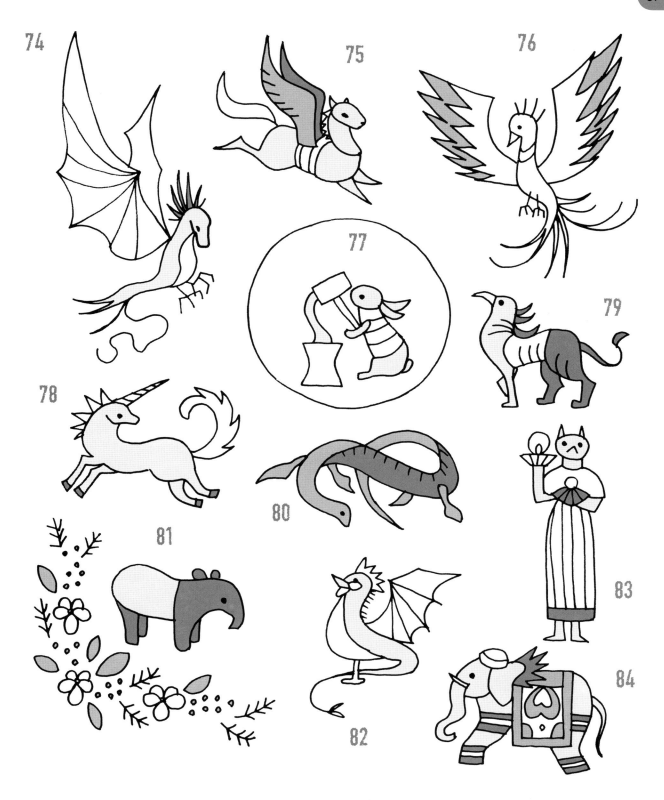

74

75

76

77

79

78

80

81

83

82

84

In the Forest

Photos: page 12

- ■ ○ = Number of strands (use 2 strands unless otherwise noted)
- ■ # = Color number
- ■ Fill with long and short stitch unless otherwise noted.
- ■ When making French knots, wrap twice unless otherwise noted.

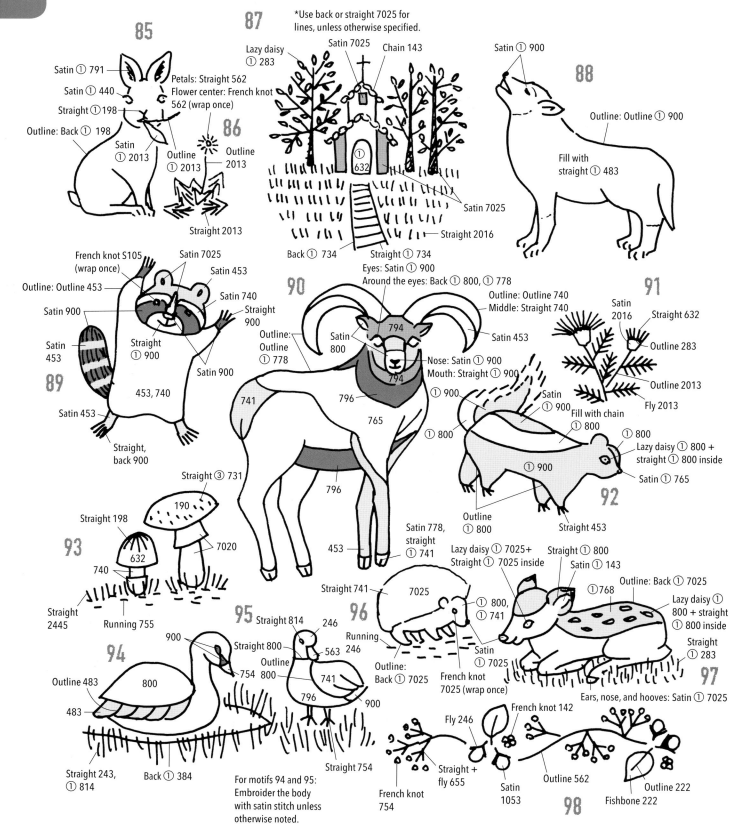

85

Satin ① 791
Satin ① 440
Straight ① 198
Outline: Back ① 198
Satin ① 2013
Outline ① 2013

86

Petals: Straight 562
Flower center: French knot 562 (wrap once)
Outline 2013
Straight 2013

87

*Use back or straight 7025 for lines, unless otherwise specified.

Lazy daisy ① 283
Satin 7025
Chain 143
Satin 7025
① 632
Back ① 734
Straight ① 734

88

Satin ① 900
Outline: Outline ① 900
Fill with straight ① 483

89

French knot S105 (wrap once)
Satin 7025
Satin 453
Outline: Outline 453
Satin 740
Satin 900
Straight 900
Satin 453
Straight ① 900
Satin 900
453, 740
Satin 453
Straight, back 900

90

Eyes: Satin ① 900
Around the eyes: Back ① 800, ① 778
Outline: Outline 740
Middle: Straight 740
Satin 800
Satin 453
794
Outline: Outline ① 778
Nose: Satin ① 900
Mouth: Straight ① 900
794
796
741
765
796
453
Satin 778, straight ① 741
Straight 741
7025

91

Satin 2016
Straight 632
Outline 283
Outline 2013
Fly 2013

92

① 900
Satin ① 900
Fill with chain ① 800
① 800
① 900
① 800
Lazy daisy ① 800 + straight ① 800 inside
Satin ① 765
Outline ① 800
Straight 453

93

Straight ③ 731
190
Straight 198
632
740
7020
Straight 2445
Running 755

94

Outline 483
800
483
Straight 243, ① 814

95

Straight 814
900
Straight 800
Outline 800
754
246
563
741
796
900
Straight 754
Back ① 384

For motifs 94 and 95: Embroider the body with satin stitch unless otherwise noted.

96

Running 246
Outline: Back ① 7025
① 800, ① 741
Satin ① 7025
French knot 7025 (wrap once)
Lazy daisy ① 7025 + Straight ① 7025 inside
Straight ① 800
Satin ① 143
① 768
Outline: Back ① 7025
Lazy daisy ① 800 + straight ① 800 inside
Straight ① 283

97

Ears, nose, and hooves: Satin ① 7025

98

Fly 246
French knot 142
Straight + fly 655
French knot 754
Satin 1053
Outline 562
Outline 222
Fishbone 222

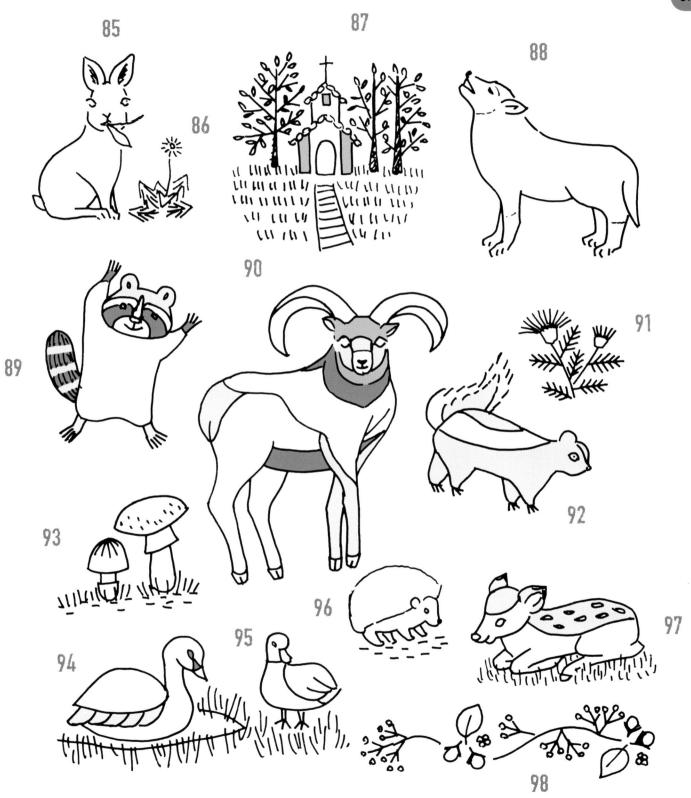

85

86

87

88

89

90

91

92

93

94

95

96

97

98

In the Forest

Photos: page 13

■ ○ = Number of strands (use 2 strands unless otherwise noted)
■ # = Color number
■ Fill with long and short stitch unless otherwise noted.
■ When making French knots, wrap twice unless otherwise noted.

99

Satin 575, 563

Satin 731

Outline 778

Straight S106 on top of satin 358

Satin 754
Straight 246

Fly 358

Fill with chain 731

Satin 451

Lazy daisy 655 + straight 655 inside

Fill with outline 575

Talons: Straight 564

100

Eyes: Straight ① 800 on top of satin ① 900
Around eyes: Back ① 800
Under eyes: Straight ① 800

Outline, straight ① 737

Satin ① 737

Satin ① 742

① 800, ① 483

① 483

Satin ① 142

Straight ① 142

Straight ① 742, ① 737

Fishbone 246

101

Eye: Straight ① S105 on top of satin ① 900
Around eye: Back 384

Straight 384

Straight ① S105
Satin 655

358

800

Straight, back ① 440

Eyes: Back ① 198, straight ① S106

Outline: Back ① 198

102

Face: ① 765
Ears: Satin ① 765

800

814

812

103

Lazy daisy 246

French knot 754

Eye: Straight ① S105 on top of satin ① 198
Around eye: Back 800

2012

283, 7020

453

Outline: Outline ① 198
Beak and feet: Straight ① 198

104

Outline 768

105

Eye: Straight ① 800 on top of satin ① 900
Around eyes: Back ① 800
Around the ear: Straight ① 900
Inside the ear: ① 765

106

Straight 900, 7025, 453, ① 741

7025

Satin ① 900

Straight 7025

Outline 741

741

Eye: Straight ① 800 on top of satin ① 900
Around eye: Back ① 7025, ① 800

Satin ① 765

Satin 562

Satin 575

Straight ① 737

Satin ① 7025

Outline: Outline ① 7025

812

① 742
812

731

108

Eyes: Straight 800 on top of satin 565
Above eyes: Straight ① 900
Under eyes: Straight ① 800

109

Satin 740

Satin 900

Satin 800

Straight 440

Outline: Outline 440

451

Straight 440

Straight ① 7025, ① 563, ① 740

Satin 190, 740

Fill with outline 2445

Outline 246

107

110

Straight 812

Satin 900
Around eye: Straight ① 731

7025

Straight 565

Straight 743, outline 743

Satin ① 765

Straight 900

Satin 7025

Ears, hips, feet, tail tip: 7025

731

734

Straight ① 731

Outline: Back ① 198

111

Straight 7025

743

Outline 768

Back 7025

112

113

Straight 602

French knot 562

Straight 143

Straight 7020

Grass: Straight 2012, 2016

Flower centers: French knot 384 (wrap once)

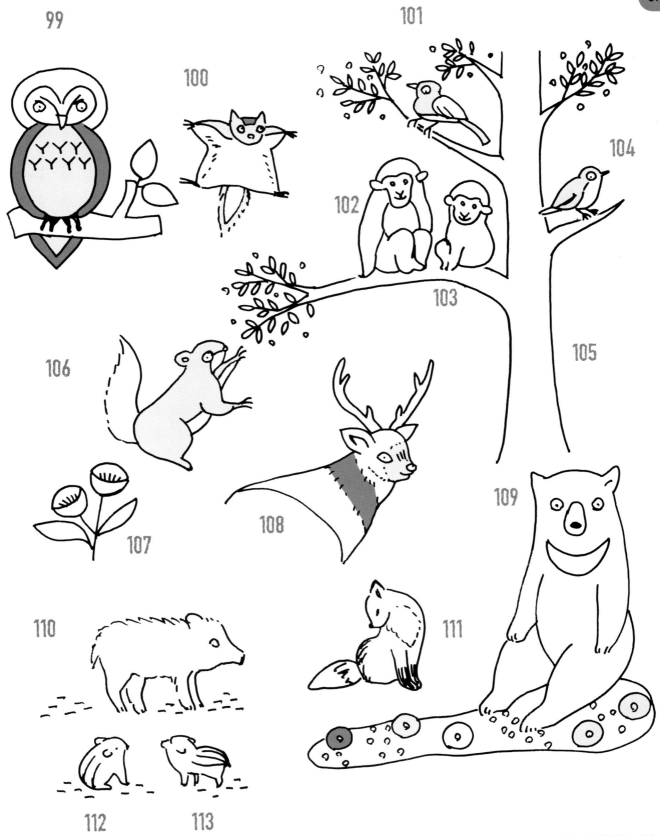

99

100

101

102

103

104

105

106

107

108

109

110

111

112 113

On the Farm

Photos: page 14

■ ○ = Number of strands (use 1 strand unless otherwise noted)
■ # = Color number

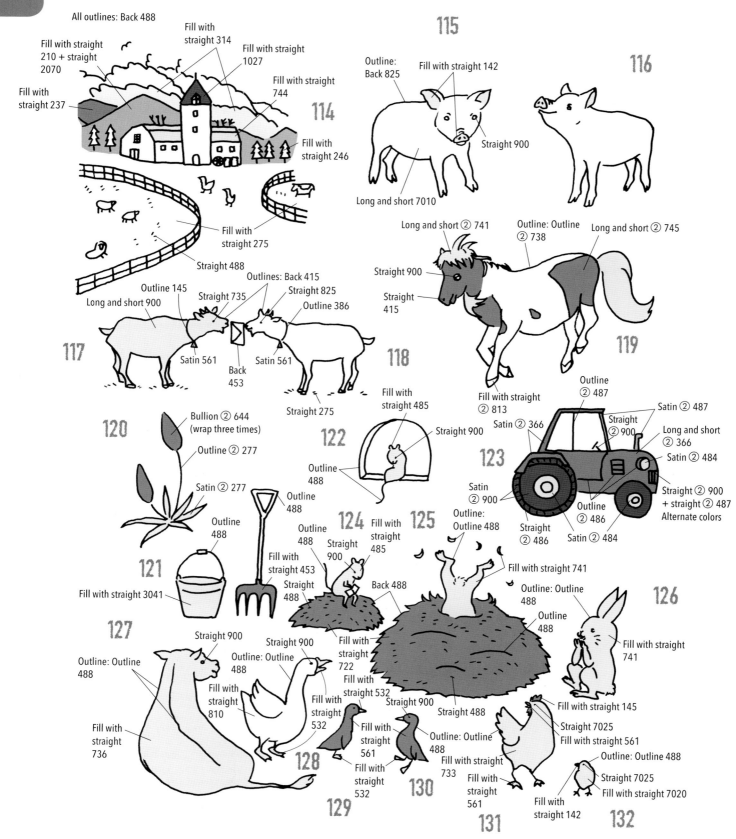

All outlines: Back 488

Fill with straight 314

Fill with straight 210 + straight 2070

Fill with straight 1027

Fill with straight 744

Fill with straight 237

Fill with straight 246

114

115

Outline: Back 825

Fill with straight 142

Straight 900

Long and short 7010

116

Long and short ② 741

Outline: Outline ② 738

Long and short ② 745

Straight 900

Straight 415

117

Outline 145

Straight 735

Outlines: Back 415

Straight 825

Outline 386

Long and short 900

Satin 561

Back 453

Satin 561

118

Straight 275

119

Fill with straight ② 813

Outline ② 487

Satin ② 366

Straight ② 900

Satin ② 487

Long and short ② 366

Satin ② 484

Straight ② 900 + straight ② 487
Alternate colors

Satin ② 900

Outline ② 486

Satin ② 484

Straight ② 486

120

Bullion ② 644 (wrap three times)

Outline ② 277

Satin ② 277

Outline 488

Fill with straight 485

Straight 900

Outline 488

122

121

Fill with straight 3041

127

Outline 488

Fill with straight 453

Straight 488

Outline 488

Straight 900

124

Fill with straight 485

Back 488

125

Outline: Outline 488

Fill with straight 741

Outline: Outline 488

Outline 488

126

Fill with straight 741

Outline: Outline 488

Straight 900

Outline: Outline 488

Fill with straight 810

Fill with straight 532

Fill with straight 532

Fill with straight 722

Fill with straight 532

Straight 900

Straight 488

Fill with straight 145

Straight 7025

Fill with straight 561

Fill with straight 736

Fill with straight 561

Fill with straight 733

Outline: Outline 488

128

129

130

131

Fill with straight 561

Outline: Outline 488

Straight 7025

Fill with straight 7020

Fill with straight 142

132

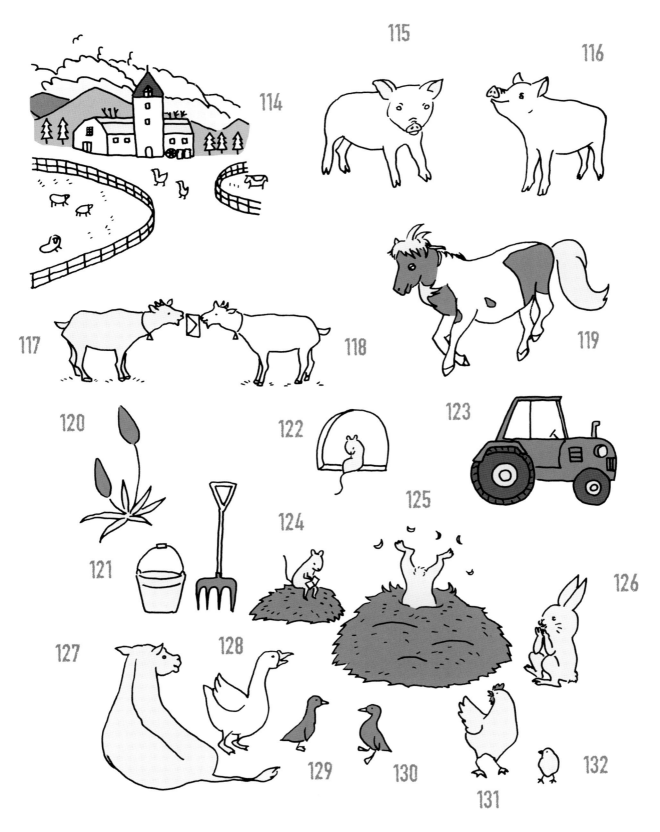

114
115
116
117
118
119
120
121
122
123
124
125
126
127
128
129
130
131
132

On the Farm

Photos: page 15

■ ○ = Number of strands (use 2 strands unless otherwise noted)
■ # = Color number

133

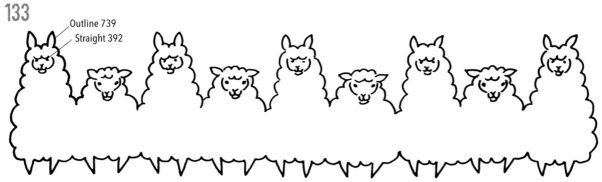

Outline 739
Straight 392

134

Long and short 413
Outline: Back ① 415
Straight, alternating ① 413 and ① 421
Long and short 421
Tail: Straight, alternating ① 413 and ① 421
Around eye: Straight 421
Eye: Straight 900
French knot 765 (wrap 3 times)
Long and short 421
Hoof: Fill with straight 413
Straight 245

135
Outline: Back ① 415
Straight ① 738
Long and short ① 900

138
Fill with straight 742
Straight 392
Outline: Outline 738
Fill with chain 733
Fill with straight 742

136
French knot 813 (wrap 3 times)
Straight ① 392
Long and short ① 900
Satin ① 900
Fill with straight ① 815

137
Fill with straight 581
Outline 275
Satin 275

139
Satin 1706
Satin 561
Straight 488
Satin 625
Satin 262
Satin 765
Straight 625

140
Outline 743
Eye: Straight 304
Pupil: Straight 825
Outline ① 486
Satin 561
Straight 739
Outline 486
Straight 237

141
Straight ① 488
Back 221
Satin 365 + straight 291
Fill with straight ① 488
Outline 900
Eye: Straight 386
Around eye: Back ① 900
Fill with straight ① 765

133

134

135

136

137

138

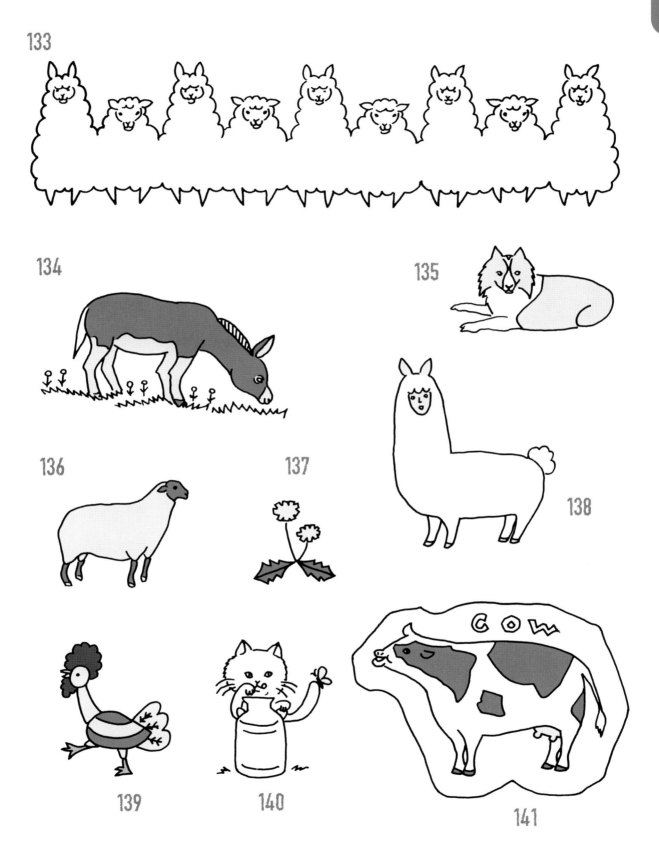

139

140

141

Small Creatures

Photos: page 16

■ ○ = Number of strands (use 2 strands unless otherwise noted)
■ # = Color number
■ When making French knots, wrap twice unless otherwise noted.

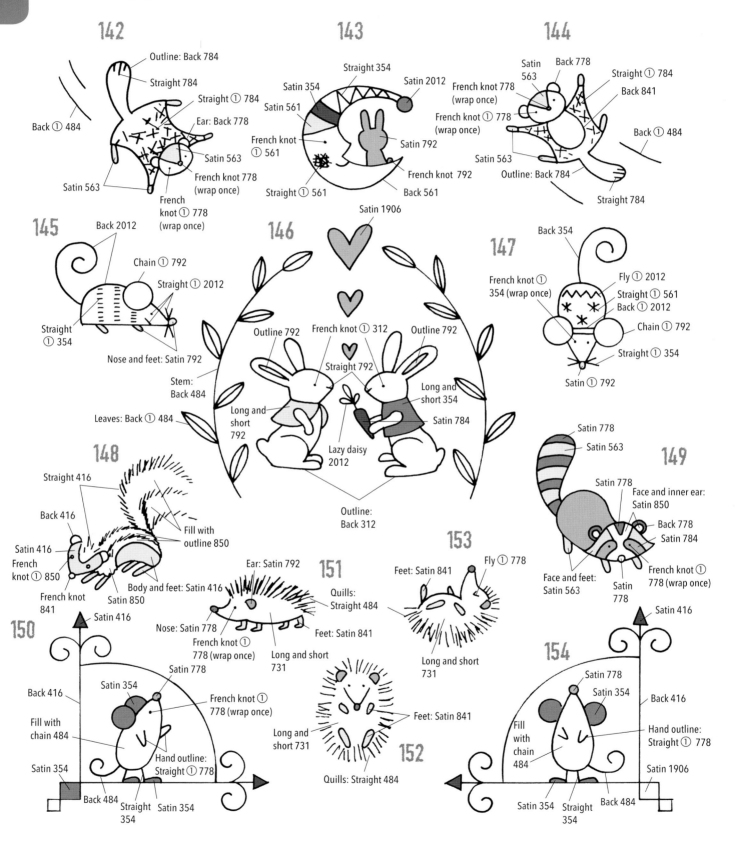

142
Outline: Back 784
Straight 784
Straight ① 784
Back ① 484
Ear: Back 778
Satin 563
French knot 778 (wrap once)
Satin 563
French knot ① 778 (wrap once)

143
Straight 354
Satin 354
Satin 561
Satin 2012
French knot ① 561
Straight ① 561
Satin 792
French knot 792
Back 561

144
Satin 563
Back 778
Straight ① 784
French knot 778 (wrap once)
Back 841
French knot ① 778 (wrap once)
Back ① 484
Satin 563
Outline: Back 784
Straight 784

145
Back 2012
Chain ① 792
Straight ① 2012
Straight ① 354
Nose and feet: Satin 792

146
Satin 1906
Outline 792
French knot ① 312
Outline 792
Straight 792
Long and short 792
Stem: Back 484
Leaves: Back ① 484
Lazy daisy 2012
Long and short 354
Satin 784
Outline: Back 312

147
Back 354
French knot ① 354 (wrap once)
Fly ① 2012
Straight ① 561
Back ① 2012
Chain ① 792
Straight ① 354
Satin ① 792

148
Straight 416
Back 416
Satin 416
French knot ① 850
Fill with outline 850
Body and feet: Satin 416
Satin 850
French knot 841

149
Satin 778
Satin 563
Satin 778
Face and inner ear: Satin 850
Back 778
Satin 784
Face and feet: Satin 563
Satin 778
French knot ① 778 (wrap once)

150
Satin 416
Back 416
Satin 354
Satin 778
French knot ① 778 (wrap once)
Fill with chain 484
Satin 354
Hand outline: Straight ① 778
Back 484
Straight 354
Satin 354

151
Ear: Satin 792
Quills: Straight 484
Nose: Satin 778
French knot ① 778 (wrap once)
Long and short 731
Feet: Satin 841

152
Long and short 731
Feet: Satin 841
Quills: Straight 484

153
Feet: Satin 841
Fly ① 778
Long and short 731

154
Satin 416
Satin 778
Satin 354
Back 416
Fill with chain 484
Hand outline: Straight ① 778
Satin 1906
Satin 354
Straight 354
Back 484

STITCH GUIDE

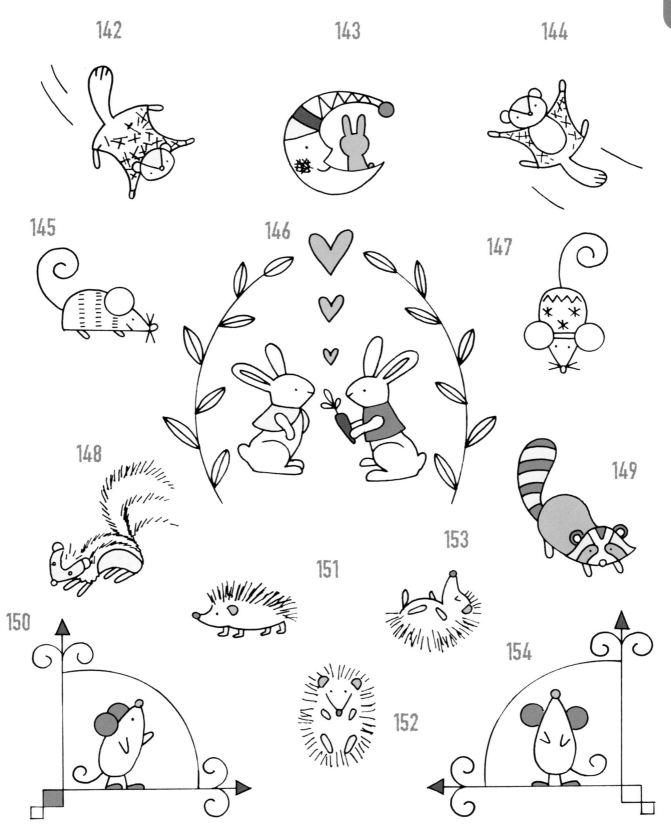

142

143

144

145

146

147

148

149

150

151

153

152

154

Small Creatures

Photos: page 17

- ■ ◯ = Number of strands (use 2 strands unless otherwise noted)
- ■ # = Color number
- ■ When making French knots, wrap twice unless otherwise noted.

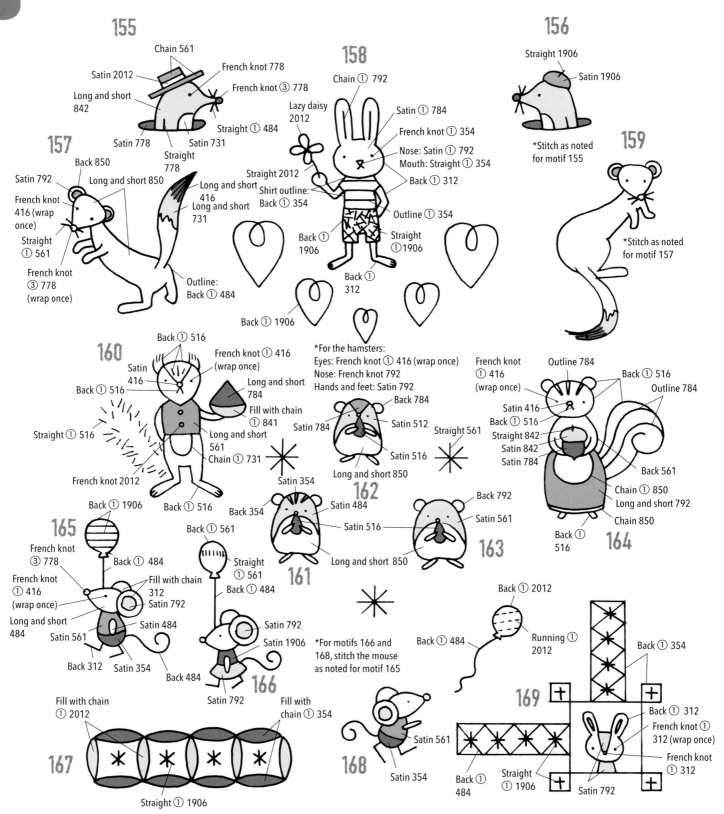

155
Chain 561
Satin 2012
French knot 778
French knot ③ 778
Long and short 842
Straight ① 484
Satin 778
Satin 731
Straight 778

158
Chain ① 792
Lazy daisy 2012
Satin ① 784
French knot ① 354
Nose: Satin ① 792
Mouth: Straight ① 354
Back ① 312
Straight 2012
Long and short 416
Long and short 731
Shirt outline: Back ① 354
Outline ① 354
Back ① 1906
Straight ① 1906
Back ① 312
Back ① 1906

156
Straight 1906
Satin 1906
*Stitch as noted for motif 155

157
Back 850
Satin 792
Long and short 850
French knot 416 (wrap once)
Straight ① 561
French knot ③ 778 (wrap once)
Long and short 416
Long and short 731
Outline: Back ① 484

159
*Stitch as noted for motif 157

160
Back ① 516
Satin 416
French knot ① 416 (wrap once)
Back ① 516
Long and short 784
Fill with chain ① 841
Straight ① 516
Long and short 561
Chain ① 731
French knot 2012
Back ① 1906
Back ① 516

*For the hamsters:
Eyes: French knot ① 416 (wrap once)
Nose: French knot 792
Hands and feet: Satin 792

Back 784
Satin 784
Satin 512
Straight 561
Satin 516
Long and short 850

162
Satin 354
Satin 484
Satin 516
Back 354
Long and short 850

161

163
Back 792
Satin 561

French knot ① 416 (wrap once)
Outline 784
Back ① 516
Outline 784
Satin 416
Back ① 516
Straight 842
Satin 842
Satin 784
Back 561
Chain ① 850
Long and short 792
Chain 850
Back ① 516

164

165
Back ① 1906
French knot ③ 778
Back ① 484
French knot ① 416 (wrap once)
Fill with chain 312
Satin 792
Long and short 484
Satin 561
Back 312
Satin 354
Back 484

Back ① 561
Straight ① 561
Back ① 484
Satin 792
Satin 1906
Satin 792

166

*For motifs 166 and 168, stitch the mouse as noted for motif 165

167
Fill with chain ① 2012
Fill with chain ① 354
Straight ① 1906

168
Satin 561
Satin 354

Back ① 2012
Back ① 484
Running ① 2012

169
Back ① 354
Back ① 312
French knot ① 312 (wrap once)
French knot ① 312
Satin 792
Back ① 484
Straight ① 1906

78 HOW TO EMBROIDER ALMOST EVERY ANIMAL

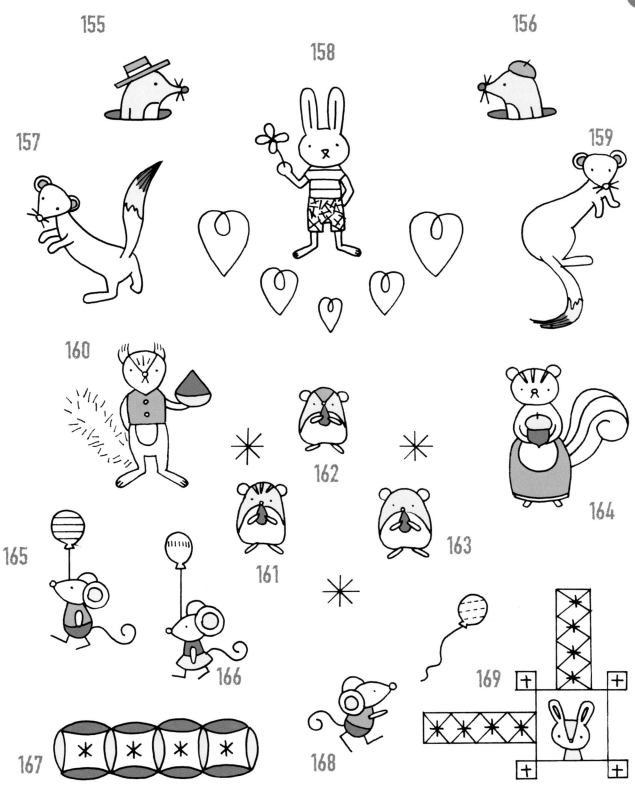

155

156

158

157

159

160

162

164

165

161

163

169

166

167

168

Zodiac Animals

Photos: page 18

■ ◯ = Number of strands (use 2 strands unless otherwise noted)
■ # = Color number
■ When making French knots, wrap twice unless otherwise noted.
■ Use backstitch ① 237 for the sign names, backstitch ② 562 for the stars, and French knot ② 485 (wrap once) for the eyes, except for motifs 175 and 179.

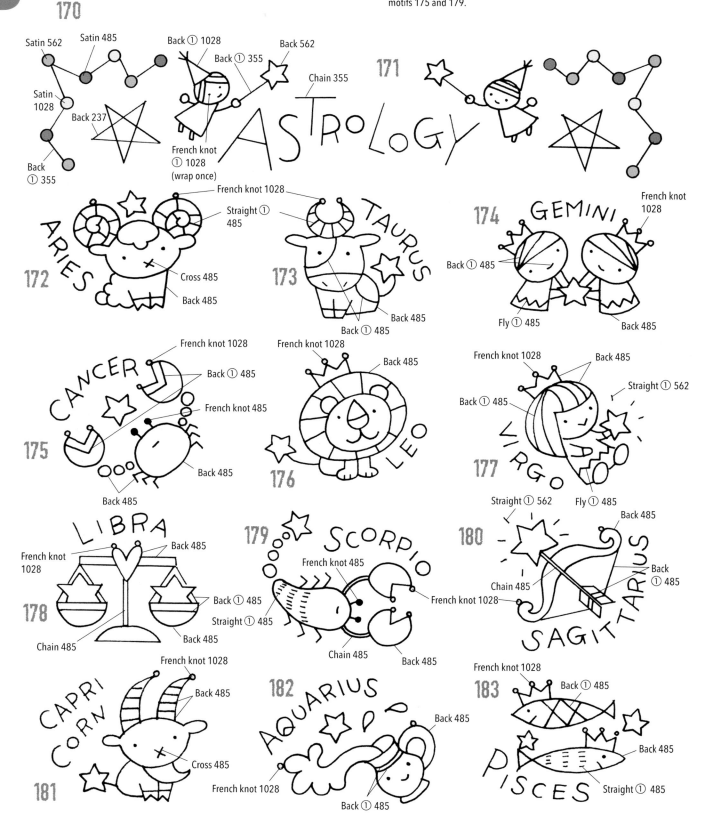

170

171

ASTROLOGY

172 ARIES

173 TAURUS

174 GEMINI

175 CANCER

176 LEO

177 VIRGO

178 LIBRA

179 SCORPIO

180 SAGITTARIUS

181 CAPRI CORN

182 AQUARIUS

183 PISCES

Animal Friends

Photos: page 19

- ■ ◯ = Number of strands (use 2 strands unless otherwise noted)
- ■ # = Color number
- ■ French knot ① 738 (wrap twice) for the eyes.
- ■ When making French knots, wrap twice unless otherwise noted.

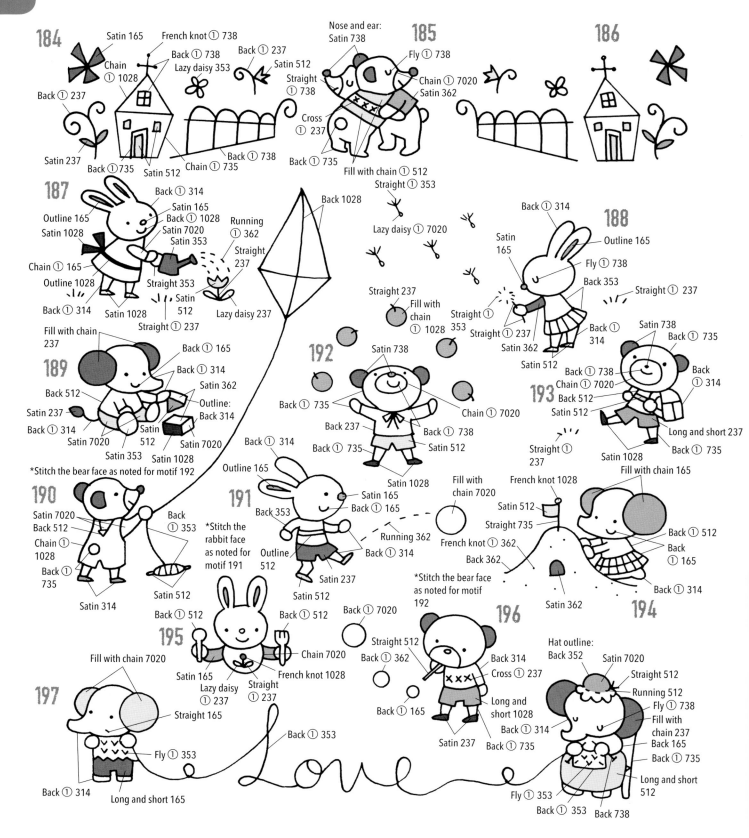

184
Satin 165
Chain ① 1028
French knot ① 738
Back ① 738
Back ① 237
Lazy daisy 353
Satin 512
Back ① 237
Satin 237
Back ① 735
Satin 512
Chain ① 735
Back ① 738

185
Nose and ear: Satin 738
Fly ① 738
Chain ① 7020
Satin 362
Straight ① 738
Cross ② 237
Back ① 735
Fill with chain ① 512

186

187
Back ① 314
Satin 165
Outline 165
Back ① 1028
Satin 1028
Satin 7020
Satin 353
Running ① 362
Straight 237
Chain ① 165
Outline 1028
Straight 353
Back ① 314
Satin 1028
Satin 512
Straight ① 237
Lazy daisy 237

Back 1028
Straight ① 353
Lazy daisy 7020

188
Back ① 314
Outline 165
Satin 165
Fly ① 738
Back 353
Straight ① 237
Back ① 314
Straight ① 237
Straight ① 353
Satin 362
Satin 512
Back ① 738
Chain ① 7020
Satin 738
Back ① 735
Back ① 314

Fill with chain 237

189
Back ① 165
Back ① 314
Satin 362
Back 512
Outline: Back 314
Satin 237
Back ① 314
Satin 512
Satin 7020
Satin 7020
Satin 353
Satin 1028

*Stitch the bear face as noted for motif 192

192
Straight 237
Fill with chain ① 1028
Satin 738
Back ① 735
Back 237
Chain ① 7020
Back ① 738
Satin 512
Back ① 735
Satin 1028

193
Back ① 735
Back ① 314
Back 512
Satin 512
Satin 1028
Long and short 237
Back ① 735
Straight ① 237
Fill with chain 165

190
Satin 7020
Back ① 353
Back 512
Chain ① 1028
Back ① 735
Satin 512
Satin 314

191
Back ① 314
Outline 165
Back 353
Satin 165
Back ① 165
*Stitch the rabbit face as noted for motif 191
Outline 512
Running 362
Back ① 314
Satin 237
Satin 512

Fill with chain 7020
French knot 1028
Satin 512
Straight 735
French knot ① 362
Back 362
*Stitch the bear face as noted for motif 192
Satin 362

194
Fill with chain 165
Back ① 512
Back ① 165
Back ① 314

195
Back ① 512
Back ① 512
Chain 7020
French knot 1028
Satin 165
Lazy daisy ① 237
Straight ① 237

Back ① 7020
Straight 512
Back ① 362
Back ① 165

196
Back 314
Cross ① 237
Long and short 1028
Back ① 314
Satin 237
Back ① 735

197
Fill with chain 7020
Straight 165
Fly ① 353
Back ① 314
Long and short 165

Hat outline: Back 352
Satin 7020
Straight 512
Running 512
Fly ① 738
Fill with chain 237
Back 165
Back ① 735
Long and short 512
Fly ① 353
Back ① 353
Back 738

184

185

186

187

188

193

189

192

190

191

194

195

196

197

Storybook Animals

Photos: page 20

- ■ ○ = Number of strands (use 2 strands unless otherwise noted)
- ■ # = Color number
- ■ Fill with satin stitch unless otherwise noted.
- ■ When making French knots, wrap once unless otherwise noted.

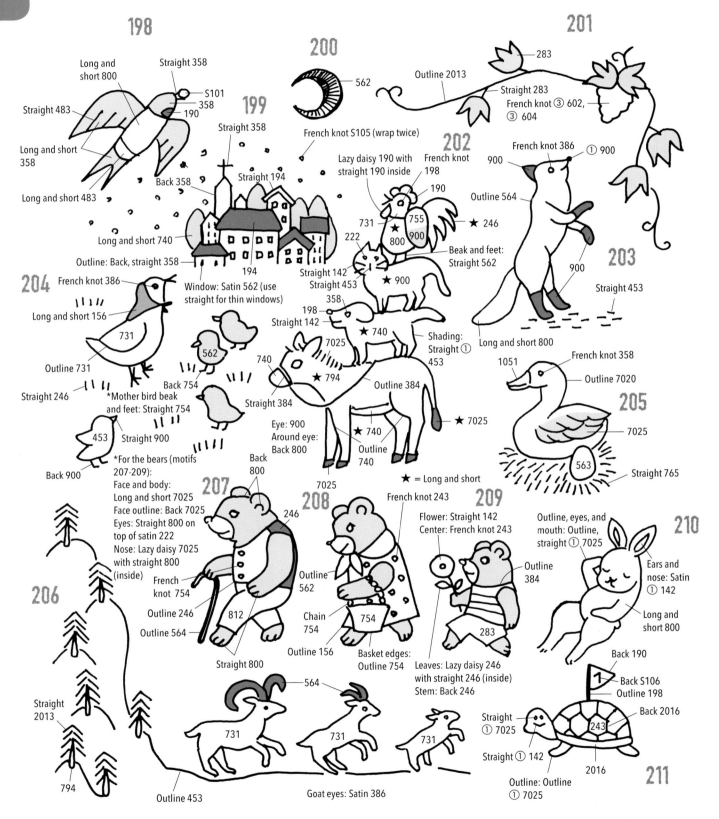

198

Long and short 800
Straight 358
S101
358
190
Straight 483
Long and short 358
Long and short 483
Long and short 740
Outline: Back, straight 358

199

Straight 358
Straight 194
Back 358
194
Window: Satin 562 (use straight for thin windows)

200

562
French knot S105 (wrap twice)

204

French knot 386
Long and short 156
731
Outline 731
Straight 246
*Mother bird beak and feet: Straight 754
562
Back 754
Straight 142
Straight 453
198 358
Straight 142
7025
740
740
★ 794
Straight 384
Back 800
Eye: 900
Around eye: Back 800
7025
★ 740
Outline 740
7025

453
Straight 900
Back 900
*For the bears (motifs 207-209):
Face and body: Long and short 7025
Face outline: Back 7025
Eyes: Straight 800 on top of satin 222
Nose: Lazy daisy 7025 with straight 800 (inside)

202

Lazy daisy 190 with straight 190 inside
French knot 198
190
731
222
755 800 900
★ 246
★ 900
Beak and feet: Straight 562
Shading: Straight ① 453
Outline 384
★ 7025
★ = Long and short

201

283
Outline 2013
Straight 283
French knot ③ 602, ③ 604
French knot 386 ① 900
900
Outline 564
900
Long and short 800

203

Straight 453

205

1051
French knot 358
Outline 7020
7025
563
Straight 765

206

Straight 2013
794

207

Back 800
246
French knot 754
Outline 246
Outline 564
812
Straight 800

208

Outline 562
Chain 754
Outline 156
754
Basket edges: Outline 754

French knot 243

209

Flower: Straight 142
Center: French knot 243
Outline 384
283
Leaves: Lazy daisy 246 with straight 246 (inside)
Stem: Back 246

210

Outline, eyes, and mouth: Outline, straight ① 7025
Ears and nose: Satin ① 142
Long and short 800

211

Back 190
Back S106
Outline 198
1
243
Back 2016
2016
Straight ① 7025
Straight ① 142
Outline: Outline ① 7025

564
731
731
731
Outline 453
Goat eyes: Satin 386

STITCH GUIDE

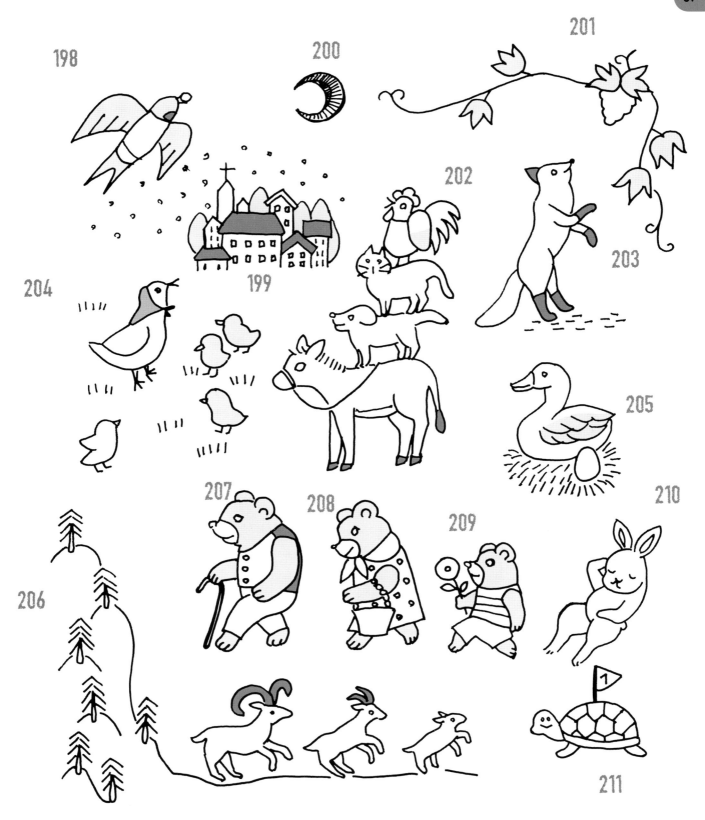

198

200

201

199

202

203

204

205

206

207

208

209

210

211

Storybook Animals

Photos: page 21

STITCH GUIDE

- ■ ○ = Number of strands (use 2 strands unless otherwise noted)
- ■ # = Color number
- ■ Fill with satin stitch unless otherwise noted.
- ■ When making French knots, wrap once unless otherwise noted.

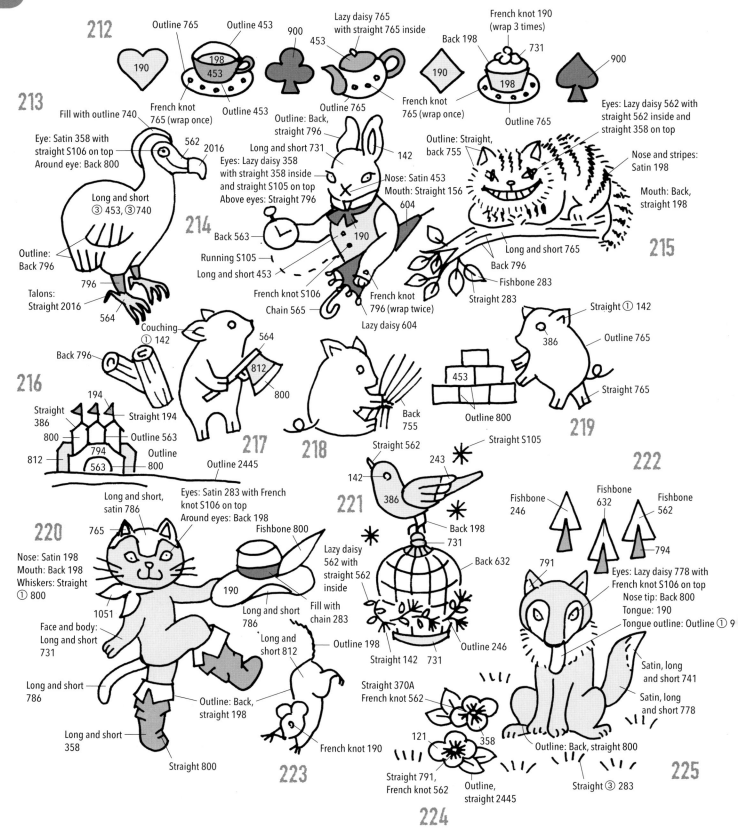

212

Outline 765

Outline 453

900

453

Lazy daisy 765
with straight 765 inside

Back 198

French knot 190
(wrap 3 times)

731

900

190

198

453

French knot
765 (wrap once)

Outline 453

Outline 765

French knot
765 (wrap once)

190

198

Outline 765

213

Fill with outline 740

Eye: Satin 358 with
straight S106 on top
Around eye: Back 800

562

2016

Long and short
③ 453, ③ 740

Outline:
Back 796

796

Talons:
Straight 2016

564

Outline: Back,
straight 796

Long and short 731

Eyes: Lazy daisy 358
with straight 358 inside
and straight S105 on top
Above eyes: Straight 796

214

Back 563

Running S105

Long and short 453

French knot S106

Chain 565

142

Nose: Satin 453
Mouth: Straight 156

604

190

French knot
796 (wrap twice)

Lazy daisy 604

Outline: Straight,
back 755

Eyes: Lazy daisy 562 with
straight 562 inside and
straight 358 on top

Nose and stripes:
Satin 198

Mouth: Back,
straight 198

Long and short 765

Back 796

Fishbone 283

Straight 283

215

216

Back 796

Couching
① 142

564

812

800

Straight 386

Straight 194

Outline 563

Outline
800

217

Straight
386

800

812

794

563

Outline 2445

Long and short,
satin 786

765

Eyes: Satin 283 with French
knot S106 on top
Around eyes: Back 198

Fishbone 800

190

Long and short
786

Fill with
chain 283

Long and
short 812

Outline 198

Long and
short 812

Outline: Back,
straight 198

French knot 190

Back
755

Outline 800

453

386

Straight ① 142

Outline 765

Straight 765

219

222

220

Nose: Satin 198
Mouth: Back 198
Whiskers: Straight
① 800

1051

Face and body:
Long and short
731

Long and short
786

Long and short
358

Straight 800

223

Straight 562

142

243

386

731

Back 198

Lazy daisy
562 with
straight 562
inside

Straight S105

Back 632

221

Outline 198

Straight 142

731

Outline 246

Straight 370A
French knot 562

121

358

Straight 791,
French knot 562

Outline,
straight 2445

224

Fishbone
246

Fishbone
632

Fishbone
562

794

791

Eyes: Lazy daisy 778 with
French knot S106 on top
Nose tip: Back 800
Tongue: 190
Tongue outline: Outline ① 9

Satin, long
and short 741

Satin, long
and short 778

Outline: Back, straight 800

Straight ③ 283

225

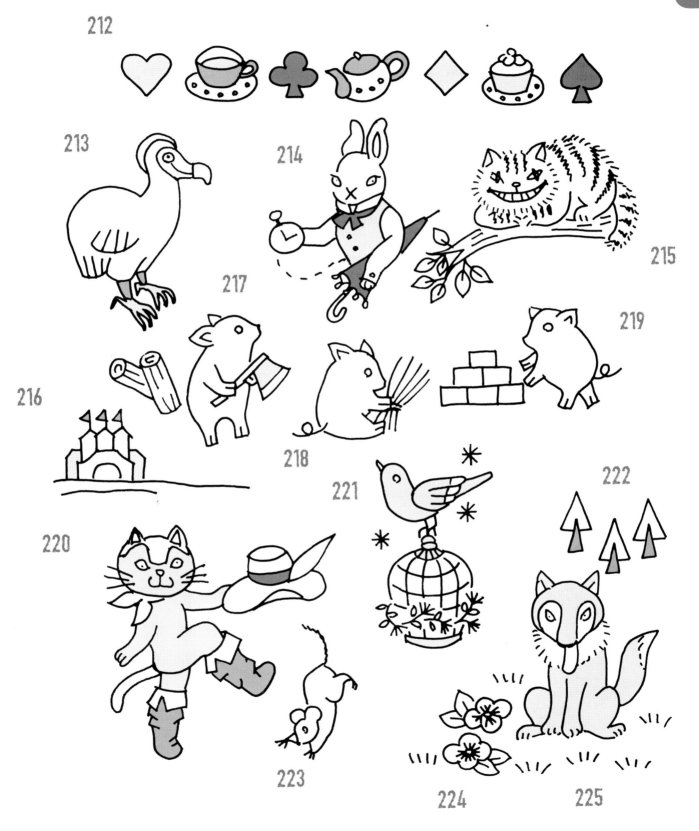

212

213

214

215

216

217

218

219

220

221

222

223

224

225


Folk Animals

Photos: page 22

- ■ ○ = Number of strands (use 2 strands unless otherwise noted)
- ■ # = Color number
- ■ Outline with backstitch ② 900 and fill with satin stitch unless otherwise noted.

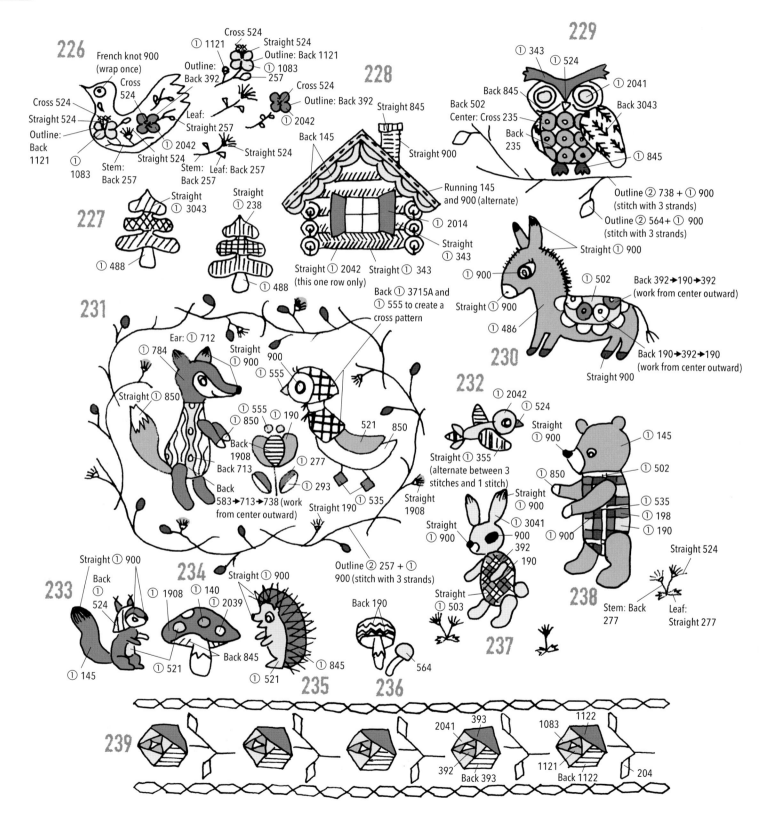

226
French knot 900 (wrap once)
Cross 524
Cross 524
Straight 524
Outline: Back 1121
① 1121
Outline: Back 392
Cross 524
① 1083
257
Cross 524
Outline: Back 392
Leaf: Straight 257
① 2042
Straight 524
Straight 524
① 1083
Stem: Back 257
Stem: Back 257
Leaf: Back 257
① 2042

227
Straight ① 3043
Straight ① 238
① 488
① 488

228
Straight 845
Back 145
Straight 900
Running 145 and 900 (alternate)
① 2014
Straight ① 343
① 900
Straight ① 343 (this one row only)
Straight ① 2042
Back ① 3715A and ① 555 to create a cross pattern

229
① 343
① 524
Back 845
① 2041
Back 502
Back 3043
Center: Cross 235
Back 235
① 845
Outline ② 738 + ① 900 (stitch with 3 strands)
Outline ② 564 + ① 900 (stitch with 3 strands)
Straight ① 900

230
Straight ① 900
① 502
Back 392→190→392 (work from center outward)
Straight ① 900
① 486
Back 190→392→190 (work from center outward)
Straight 900

231
Ear: ① 712
① 784
Straight ① 900
Straight ① 850
① 555
① 850
① 190
Back 1908
Back 713
900
① 555
Back 583→713→738 (work from center outward)
① 277
① 293
Straight 190
① 535
Straight 1908
521
850
Straight 1908

232
① 2042
① 524
Straight ① 900
Straight ① 355 (alternate between 3 stitches and 1 stitch)
① 850
Straight ① 900
Straight ① 900
① 3041
900
392
190
Straight ① 503
Outline ② 257 + ① 900 (stitch with 3 strands)
Back 190

238
① 145
① 502
① 900
① 535
① 198
① 190
Straight 524
Stem: Back 277
Leaf: Straight 277

233
Straight ① 900
Back ① 524
① 1908
① 145

234
① 140
① 2039
Straight ① 900
Straight ① 900
Back 845
① 521
① 845
① 521

235

236
564

237

239
2041
393
392
Back 393
1083
1122
1121
Back 1122
204

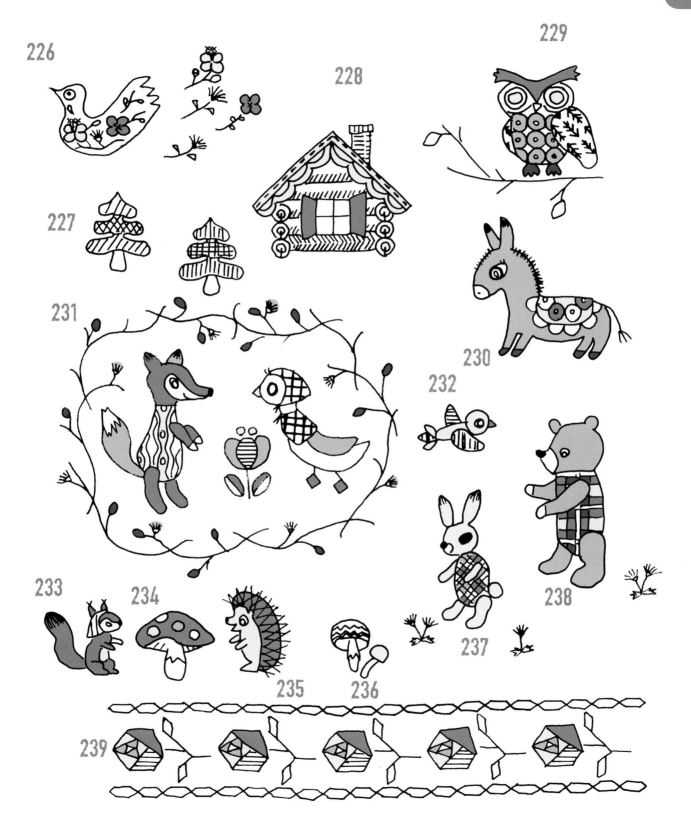

226

228

229

227

231

230

232

233 234 235 236 237 238

239

Folk Animals

Photos: page 23

- ■ ◯ = Number of strands (use 2 strands unless otherwise noted)
- ■ # = Color number
- ■ Outline with backstitch ② 900 and fill with satin stitch unless otherwise noted.

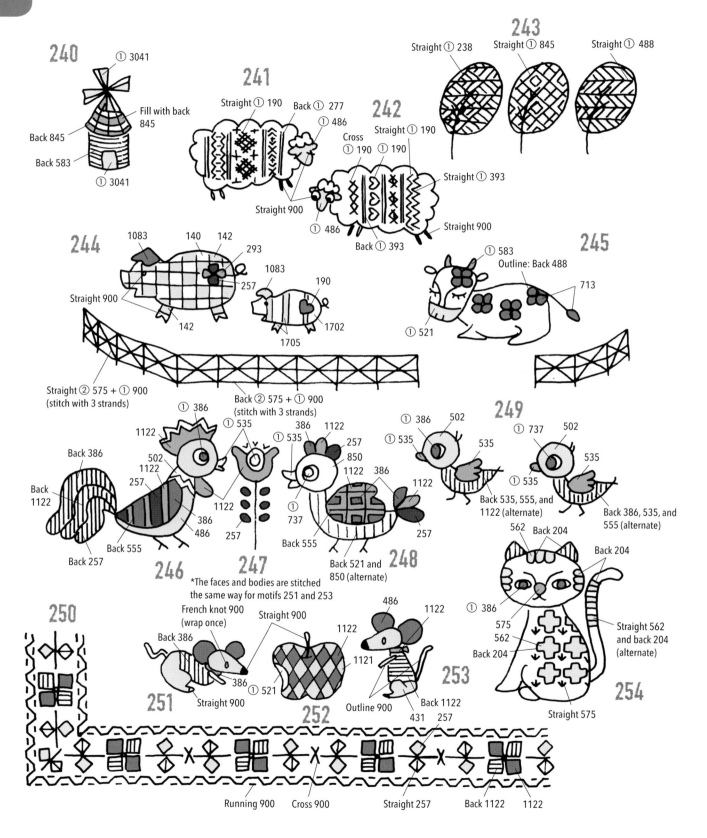

240
① 3041
Fill with back 845
Back 845
Back 583
① 3041

241
Straight ① 190
Back ① 277
① 486
Straight 900

242
Cross ① 190
Straight ① 190
① 190
① 486
Back ① 393
Straight ① 393
Straight 900

243
Straight ① 238
Straight ① 845
Straight ① 488

244
1083
140
142
293
1083
257
190
Straight 900
142
1705
1702

245
① 583
Outline: Back 488
713
① 521

Straight ② 575 + ① 900
(stitch with 3 strands)
Back ② 575 + ① 900
(stitch with 3 strands)

246
① 386
1122
502
1122
257
Back 386
Back 1122
386
486
Back 555
Back 257

247
① 535
① 535
1122
257
*The faces and bodies are stitched the same way for motifs 251 and 253

248
① 386
① 535
1122
386
257
850
1122
386
① 737
1122
257
Back 521 and 850 (alternate)
Back 555

249
① 386
① 535
502
535
① 737
502
535
① 535
Back 535, 555, and 1122 (alternate)
Back 386, 535, and 555 (alternate)

250

251
French knot 900 (wrap once)
Back 386
Straight 900
386
① 521
Straight 900

252
Straight 900
486
1122
1121

253
1122
486
Outline 900
431
257
Back 1122

254
562
Back 204
Back 204
① 386
575
562
Back 204
Straight 562 and back 204 (alternate)
Straight 575

Running 900
Cross 900
Straight 257
Back 1122
1122

240

241

242

243

244

245

246

247

248

249

250

251

252

253

254

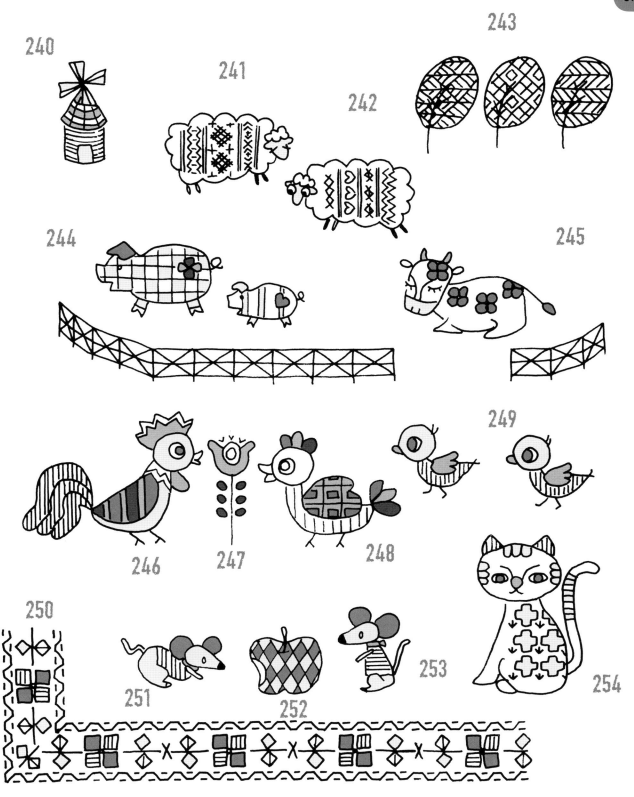

Beautiful Birds

Photos: page 24

- ■ ⟨◯⟩ = Number of strands (use 2 strands unless otherwise noted)
- ■ # = Color number
- ■ For areas marked with ★ symbols, use straight stitch to fill the bird heads and bodies following the flow of the feathers.
- ■ For the remaining areas, outline with outline stitch and fill with satin stitch unless otherwise noted.
- ■ Use satin stitch ① 900 with a small straight stitch ① 800 on top for the eyes.
- ■ Use satin stitch ① 900 for the beaks unless otherwise noted.

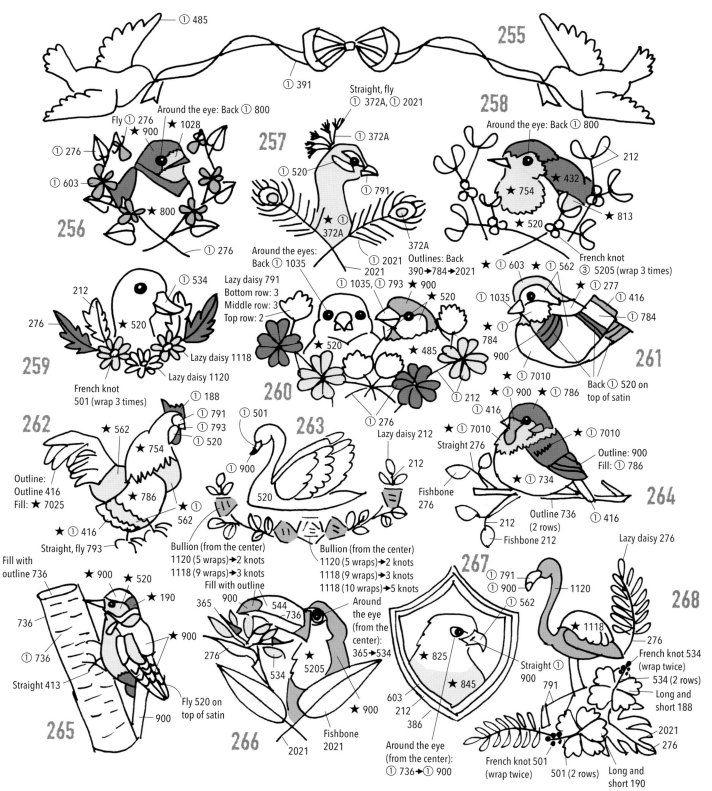

① 485

255

① 391

Straight, fly
① 372A, ① 2021

258

Around the eye: Back ① 800

257
① 372A

① 520

① 791

★ ① 372A

Around the eye: Back ① 800

212

★ 432

★ 754

★ 813

① 520

French knot
③ 5205 (wrap 3 times)

256

Fly ① 276
★ 900 ★ 1028

① 276

① 603

★ 800

① 276

Around the eyes:
Back ① 1035

Lazy daisy 791
Bottom row: 3
Middle row: 3
Top row: 2

① 1035, ① 793 ★ 900

★ 520

Lazy daisy 1118

Lazy daisy 1120

★ ① 603 ★ ① 562

① 1035

★ ① 277

★ ①
784

① 416

① 784

900

261

212

① 534

★ 520

276

259

French knot
501 (wrap 3 times)

★ 520

★ 485

① 212

① 276

Lazy daisy 212

★ ① 7010

★ ① 900 ★ ① 786

① 416

★ ① 7010

Back ① 520 on
top of satin

262

★ 562

① 188

① 791

① 793

① 520

① 501

263

263

① 900

520

562

★ ①

★ ① 416

Straight, fly 793

Outline:
Outline 416
Fill: ★ 7025

★ 754

★ 786

Bullion (from the center)
1120 (5 wraps)➜2 knots
1118 (9 wraps)➜3 knots
Fill with outline

Bullion (from the center)
1120 (5 wraps)➜2 knots
1118 (9 wraps)➜3 knots
1118 (10 wraps)➜5 knots

Straight 276

Fishbone
276

① 416

★ ① 7010

Outline: 900
Fill: ① 786

★ ① 734

Outline 736
(2 rows)

212

① 416

264

Fishbone 212

Lazy daisy 276

Fill with
outline 736

★ 900 ★ 520

★ 190

★ 900

736

① 736

Straight 413

Fly 520 on
top of satin

900

265

365

900

544
736

276

534

5205

★ 900

Around the
eye (from the
center):
365➜534

Fishbone
2021

266

2021

267

① 791
① 900

① 562

★ 825

★ 845

603
212
386

Around the eye
(from the center):
① 736➜① 900

Straight ①
900

791

French knot 501
(wrap twice)

1120

★ 1118

Lazy daisy 276

268

276

French knot 534
(wrap twice)

534 (2 rows)

Long and
short 188

2021

276

501 (2 rows)

Long and
short 190

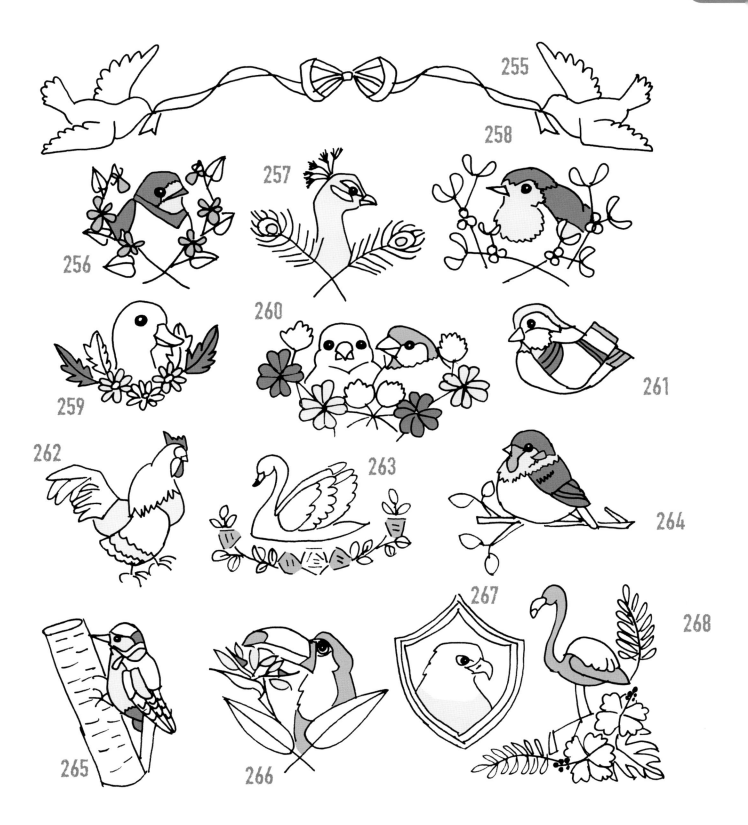

Beautiful Birds

Photos: page 25

- ■ ○ = Number of strands (use 2 strands unless otherwise noted)
- ■ # = Color number
- ■ For areas marked with ★ symbols, use straight stitch to fill the bird heads and bodies following the flow of the feathers.
- ■ For the remaining areas, outline with outline stitch and fill with satin stitch unless otherwise noted.
- ■ Use satin stitch ① 900 with a small straight stitch ① 800 on top for the eyes.
- ■ Use satin stitch ① 900 for the beaks unless otherwise noted.

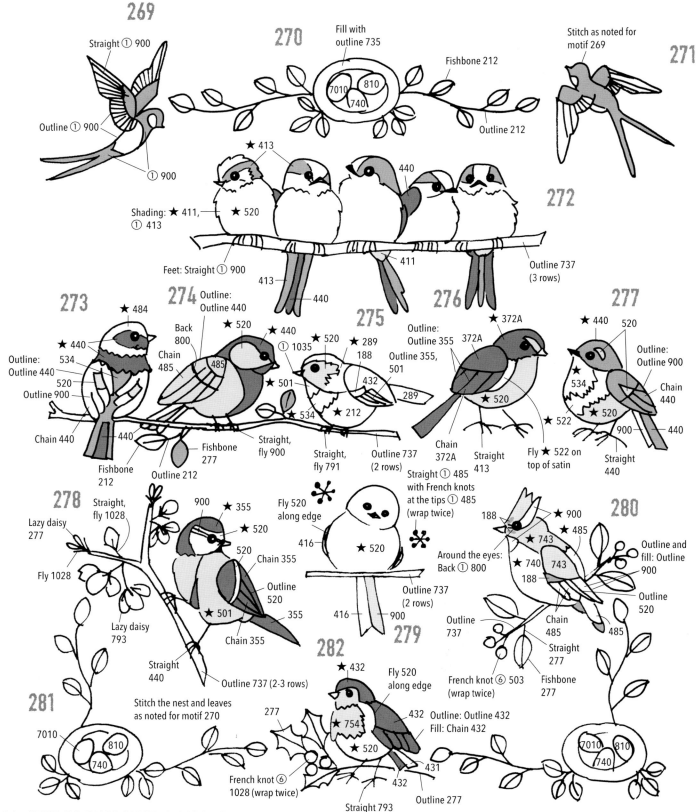

269

270

271

272

273

274

275

276

277

278

279

280

281

282

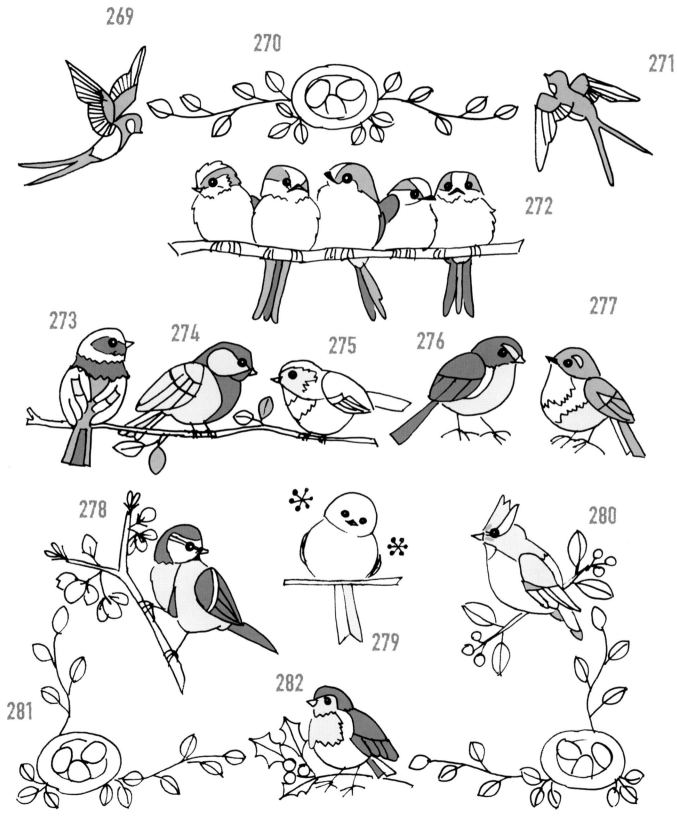

Pretty Parakeets

Photos: page 26

- ■ ○ = Number of strands (use 1 strand unless otherwise noted)
- ■ # = Color number
- ■ For areas marked with ★ symbols, use straight stitch to fill the bird heads and bodies following the flow of the feathers.
- ■ For the remaining areas, fill with satin stitch unless otherwise noted.
- ■ Use satin stitch ① 900 with a small straight stitch ① 800 on top for the eyes.

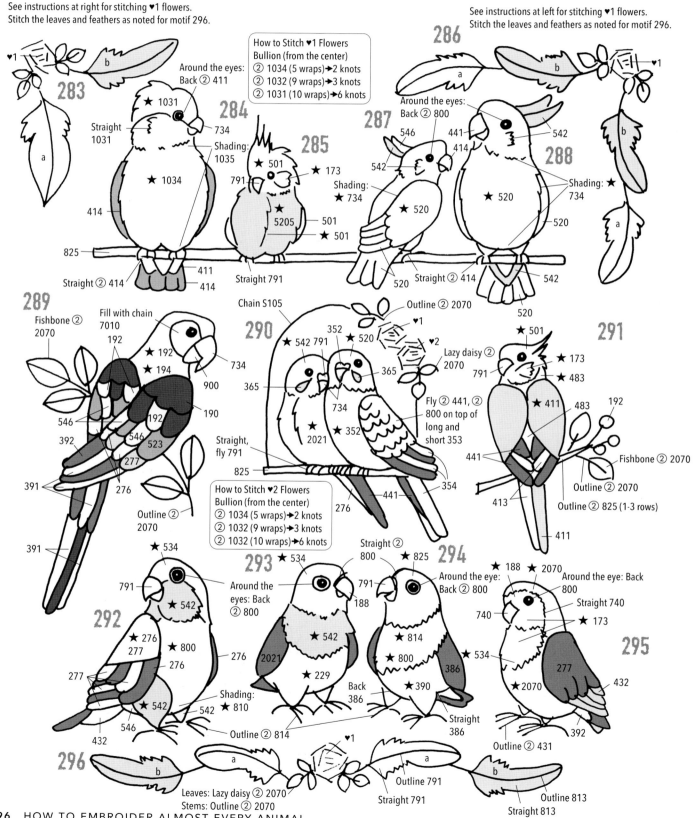

See instructions at right for stitching ♥1 flowers.
Stitch the leaves and feathers as noted for motif 296.

See instructions at left for stitching ♥1 flowers.
Stitch the leaves and feathers as noted for motif 296.

How to Stitch ♥1 Flowers
Bullion (from the center)
② 1034 (5 wraps)➔2 knots
② 1032 (9 wraps)➔3 knots
② 1031 (10 wraps)➔6 knots

283
♥1
a
b

284
1031
Straight 1031
734
★ 1034
Shading: 1035
414
825
★ 1034
Around the eyes: Back ② 411
Straight ② 414
411
414

285
★ 501
173
791
★ 5205
501
★ 501
Straight 791

287
Around the eyes: Back ② 800
546
441
414
542
★ 734
★ 520
520
Straight ② 414
520

286
a
b
♥1

288
542
★ 520
520
Shading: ★ 734
542
520

289
Fishbone ② 2070
Fill with chain 7010
192
★ 192
★ 194
900
734
192
190
546
392
546
523
277
391
276
391
Outline ② 2070

290
Chain S105
352
★ 542 791
★ 520
365
365
734
★ 2021
★ 352
Straight, fly 791
825
276
441
354
Outline ② 2070
♥1
♥2
Lazy daisy ② 2070
Fly ② 441, ② 800 on top of long and short 353

How to Stitch ♥2 Flowers
Bullion (from the center)
② 1034 (5 wraps)➔2 knots
② 1032 (9 wraps)➔3 knots
② 1032 (10 wraps)➔6 knots

291
★ 501
173
791
★ 483
★ 411
483
192
441
Fishbone ② 2070
Outline ② 2070
413
Outline ② 825 (1-3 rows)
411

292
★ 534
791
★ 542
★ 276
277
★ 800
276
277
★ 542
546
432
Around the eyes: Back ② 800

293
★ 534
188
★ 542
2021
★ 229
Shading: ★ 810
276
542
Outline ② 814

294
Straight ② 800
791
★ 825
★ 814
★ 800
Back 386
★ 390
Straight 386
386
Around the eye: Back ② 800

295
★ 188
★ 2070
Around the eye: Back 800
740
Straight 740
★ 173
★ 534
★ 2070
277
432
392
Outline ② 431

296
a
b
♥1
a
b
Leaves: Lazy daisy ② 2070
Stems: Outline ② 2070
Outline 791
Straight 791
Outline 813
Straight 813

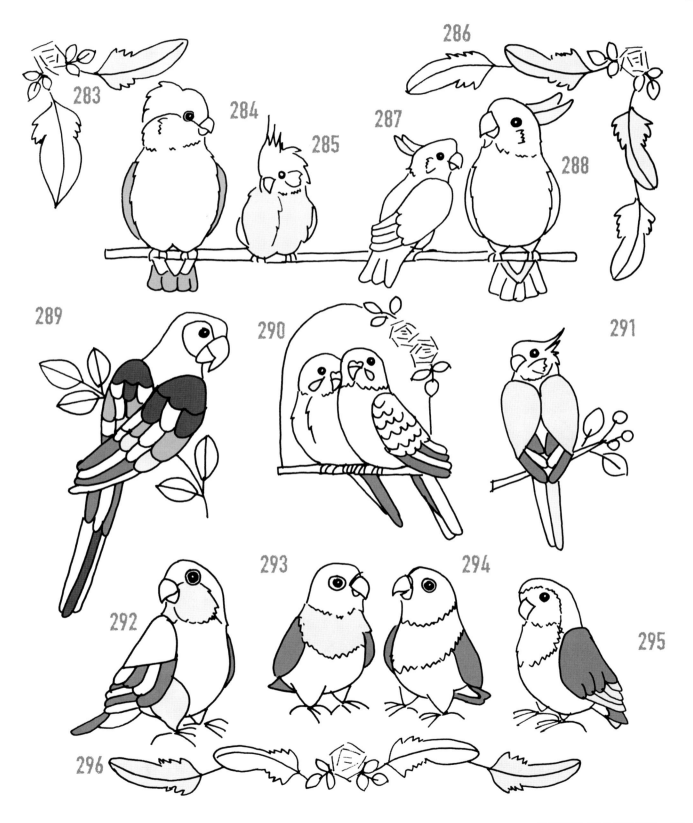

283
286
284
287
285
288

289
290
291

292
293
294
295

296

Stylish Animals

Photos: page 27

- ■ ◯ = Number of strands (use 2 strands unless otherwise noted)
- ■ # = Color number
- ■ Outline with outline stitch ② and fill with satin stitch ② unless otherwise noted.
- ■ When making French knots, wrap twice unless otherwise noted.
- ■ For the eyes, use satin stitch in Color A with a small straight stitch in Color B on top.

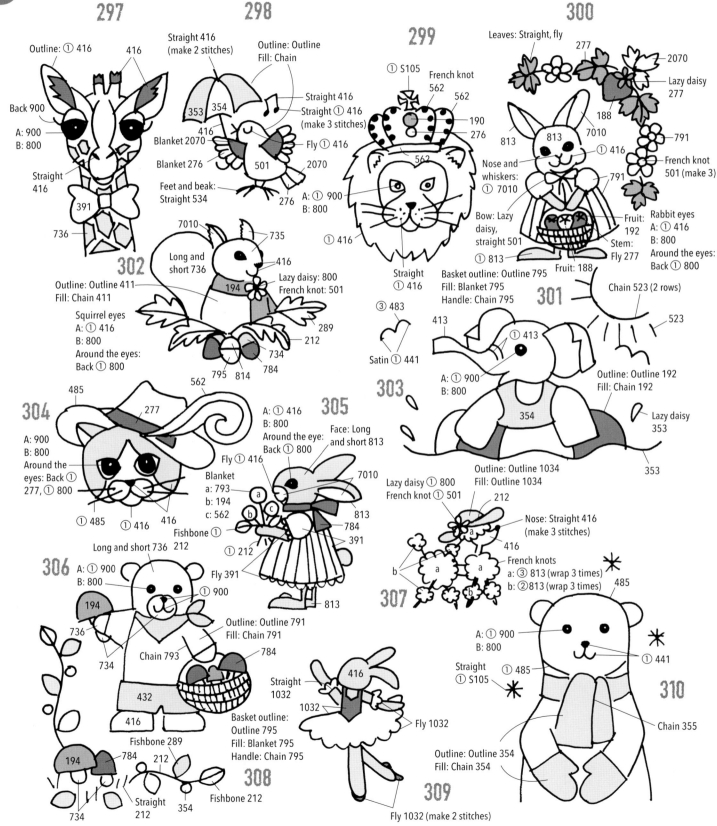

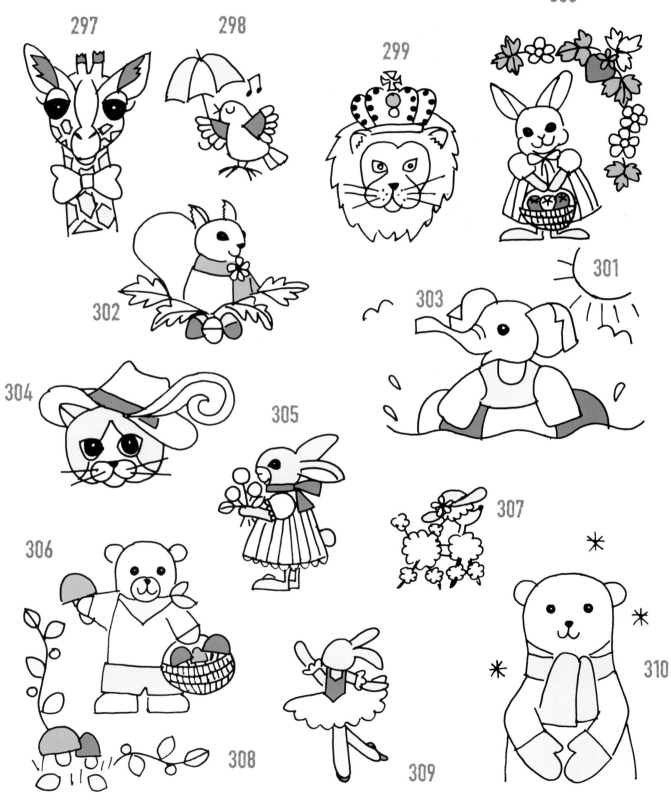

297
298
299
300
302
301
303
304
305
306
307
308
309
310

Dashing Dogs

Photos: page 28

- ○ = Number of strands
- # = Color number
- Outline with chain stitch ② 900 and fill with chain stitch ③ unless otherwise noted.
- Chain stitch ③ 900 for the eyes and noses unless otherwise noted.
- Straight stitch ③ 900 for the toes unless otherwise noted.
- Fill areas that are too small to chain stitch with straight or satin stitch.
- To make the eye highlights, French knot ② 800 (wrap once) for motifs 311–314, 316–320, and 323.

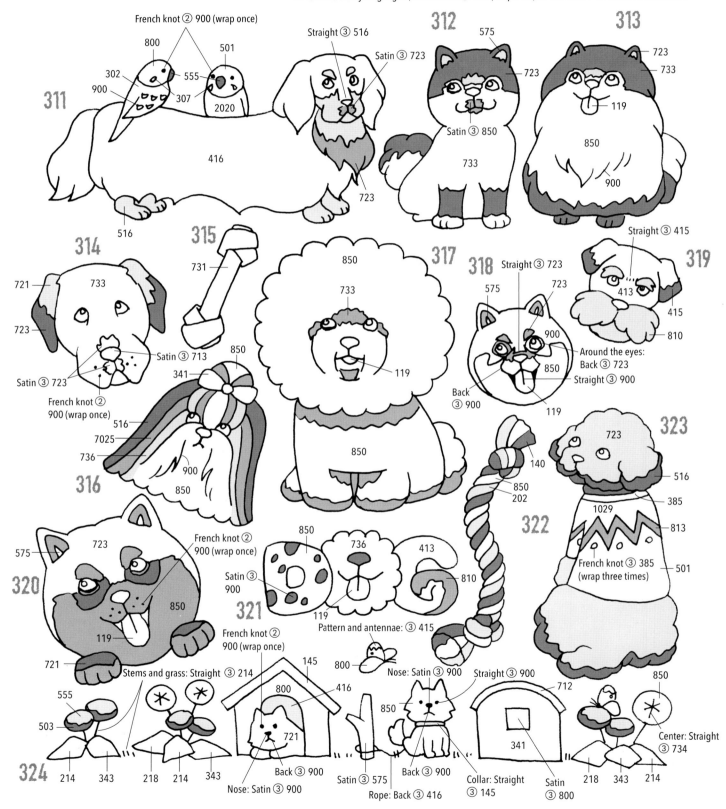

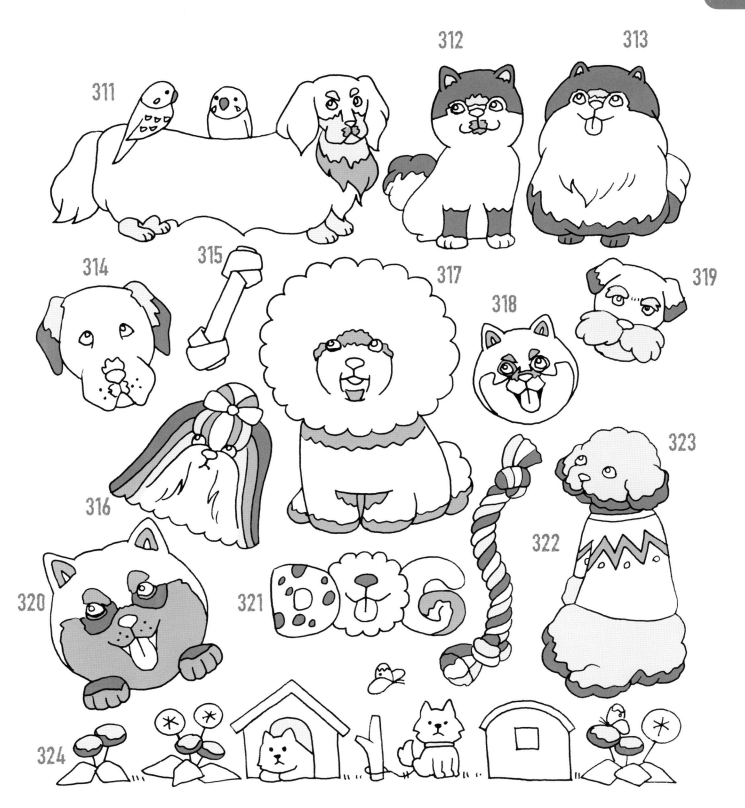

311

312 313

314 315 317 319

318

316 323

321 322

320

324

Dashing Dogs

Photos: page 29

- ○ = Number of strands
- # = Color number
- Outline with chain stitch ② 900 and fill with chain stitch ③ unless otherwise noted.
- Chain stitch ③ 900 for the eyes and noses unless otherwise noted.
- Straight stitch ③ 900 for the toes unless otherwise noted.
- Fill areas that are too small to chain stitch with straight or satin stitch.
- To make the eye highlights, French knot ② 800 (wrap once) for motifs 325, 328, 331, 334, 337, and 338.

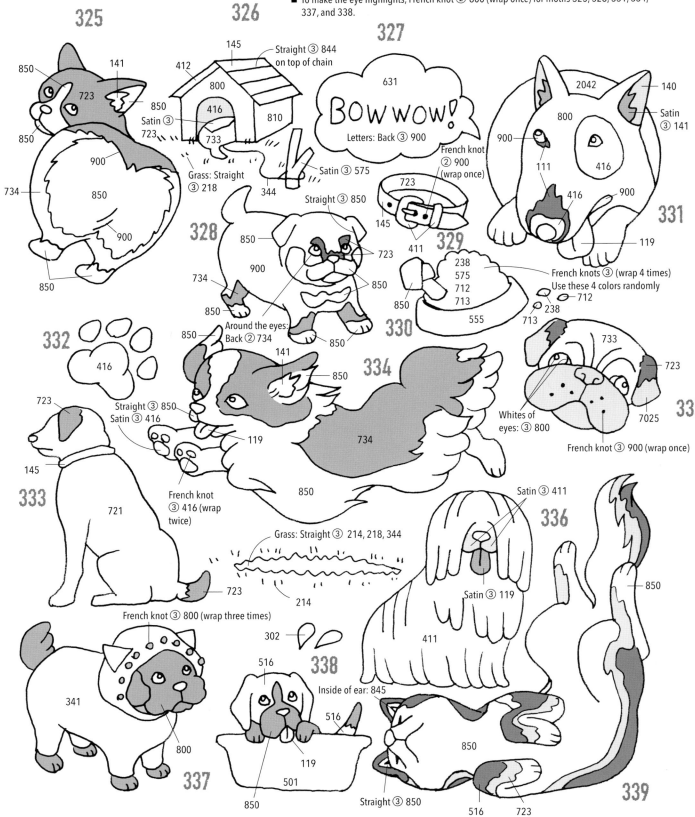

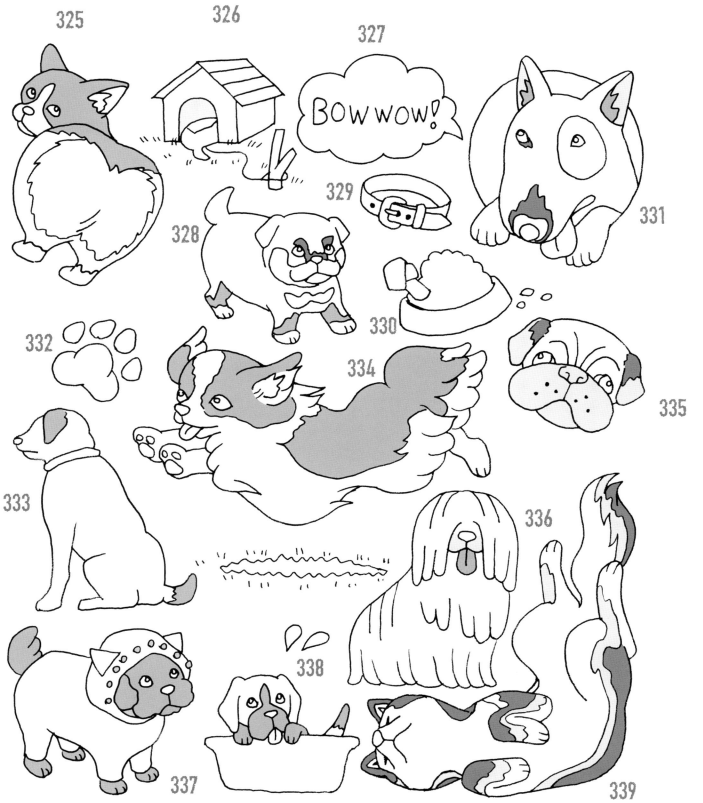

325
326
327
329
331
328
330
332
334
335
333
336
337
338
339

Curious Cats

Photos: page 30

- ○ = Number of strands
- # = Color number
- Outline with chain stitch ② 900 and fill with chain stitch ③ unless otherwise noted.
- Backstitch ② 416 for the whiskers unless otherwise noted.
- Straight stitch ③ 900 for the toes unless otherwise noted.
- Fill areas that are too small to chain stitch with straight or satin stitch.

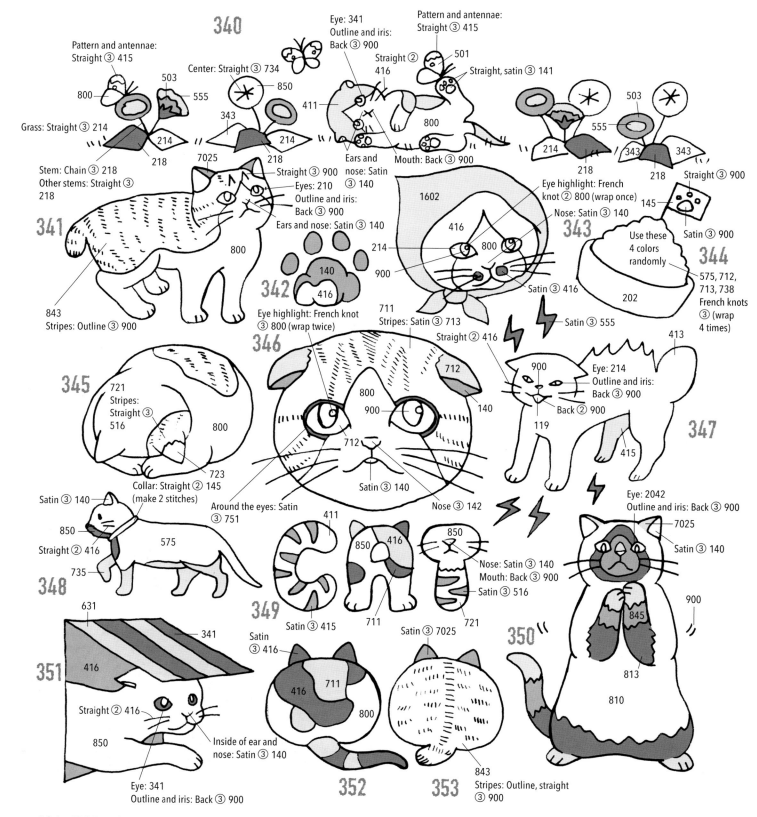

340

341 342 343 344

345 346 347

348 349 350

351 352 353

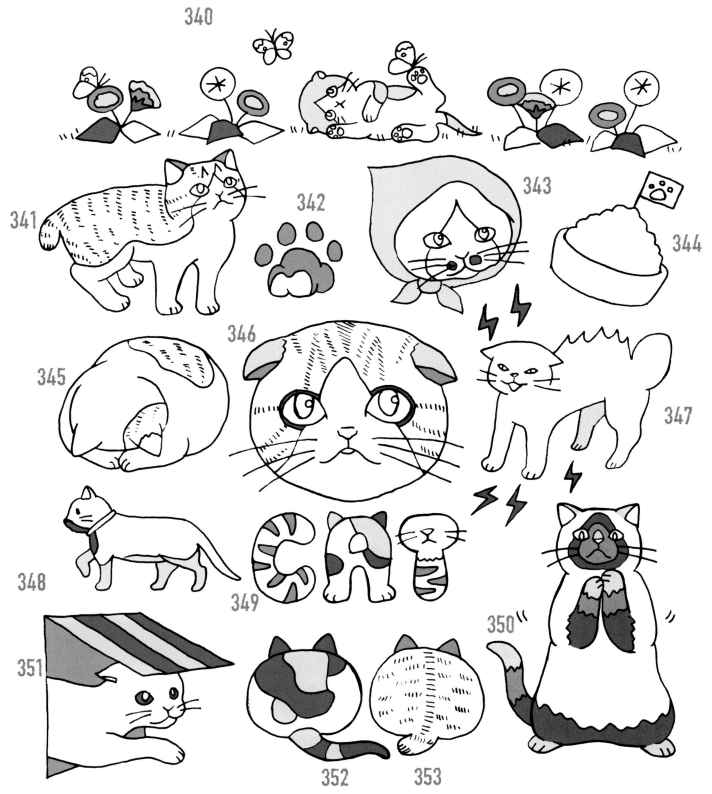

Curious Cats

Photos: page 31

STITCH GUIDE

- ■ ◯ = Number of strands
- ■ # = Color number
- ■ Outline with chain stitch ② 900 and fill with chain stitch ③ unless otherwise noted.
- ■ Backstitch ② 416 for the whiskers unless otherwise noted.
- ■ Straight stitch ③ 900 for the toes unless otherwise noted.
- ■ Fill areas that are too small to chain stitch with straight or satin stitch.

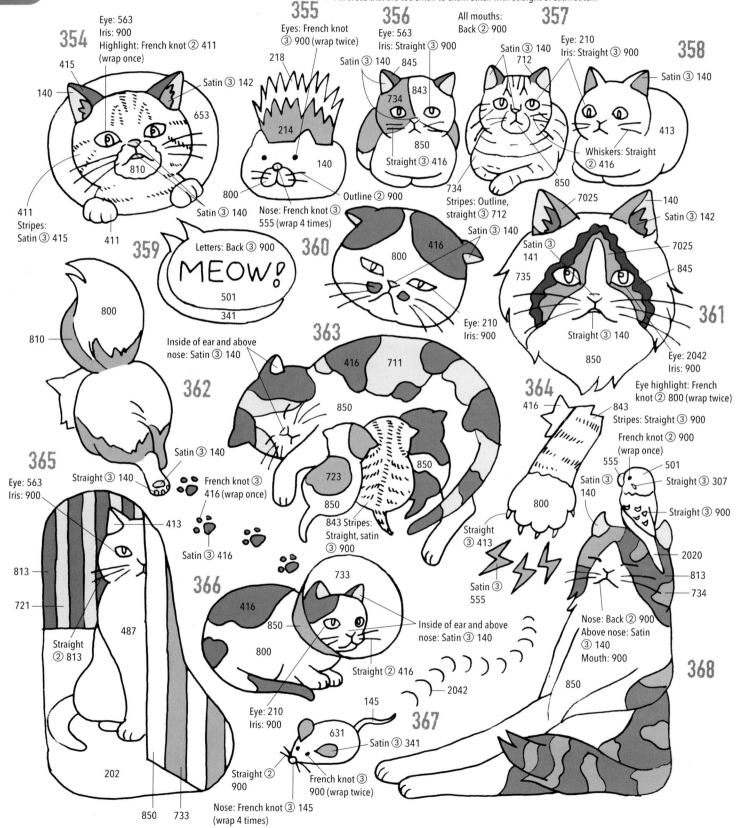

354
Eye: 563
Iris: 900
Highlight: French knot ② 411 (wrap once)
415
140
Satin ③ 142
653
810
411
411
Stripes: Satin ③ 415
Satin ③ 140

355
Eyes: French knot ③ 900 (wrap twice)
218
214
140
800
Nose: French knot ③ 555 (wrap 4 times)

356
Eye: 563
Iris: Straight ③ 900
Satin ③ 140
845
843
734
850
Straight ③ 416
Outline ② 900

357
All mouths:
Back ② 900
Satin ③ 140
712
Eye: 210
Iris: Straight ③ 900
734
850
734
Whiskers: Straight ② 416
Stripes: Outline, straight ③ 712

358
Satin ③ 140
413

359
Letters: Back ③ 900
MEOW!
501
341

360
800
416
Satin ③ 140
Eye: 210
Iris: 900

361
7025
140
Satin ③ 142
Satin ③ 141
7025
735
845
Straight ③ 140
850
Eye: 2042
Iris: 900
Eye highlight: French knot ② 800 (wrap twice)

362
810
800
Satin ③ 140
Straight ③ 140
French knot ③ 416 (wrap once)
413
Satin ③ 416
Inside of ear and above nose: Satin ③ 140

363
416
711
850
723
850
843 Stripes: Straight, satin ③ 900

364
416
800
Straight ③ 413
Satin ③ 555
843
Stripes: Straight ③ 900
French knot ② 900 (wrap once)
555
501
Straight ③ 307
Satin ③ 140
Straight ③ 900
2020
813
734
Nose: Back ② 900
Above nose: Satin ③ 140
Mouth: 900

365
Eye: 563
Iris: 900
813
721
487
Straight ② 813
202
850
733

366
733
416
850
800
Inside of ear and above nose: Satin ③ 140
Straight ② 416
Eye: 210
Iris: 900
Straight ② 900
Nose: French knot ③ 145 (wrap 4 times)

367
145
631
Satin ③ 341
2042
French knot ③ 900 (wrap twice)

368
850

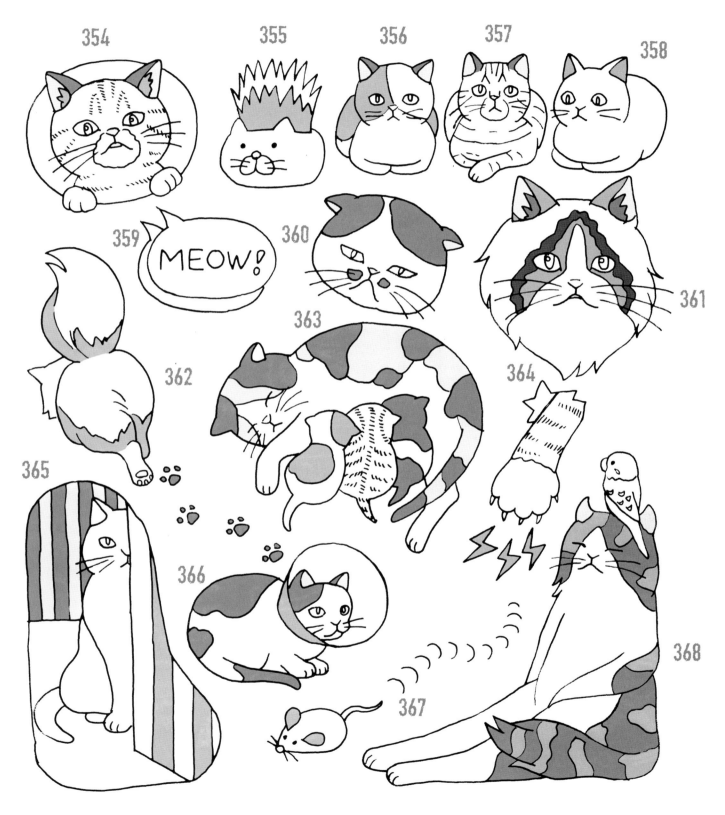

354

355

356

357

358

359

360

MEOW!

361

362

363

364

365

366

367

368

Animal Emblems

Photos: page 32

- ■ ◯ = Number of strands (use 2 strands unless otherwise noted)
- ■ Use 900 for all motifs.
- ■ Outline with outline stitch ② and fill with satin stitch ② unless otherwise noted.
- ■ Use backstitch ① for the letters unless otherwise noted.
- ■ When making French knots, wrap twice.

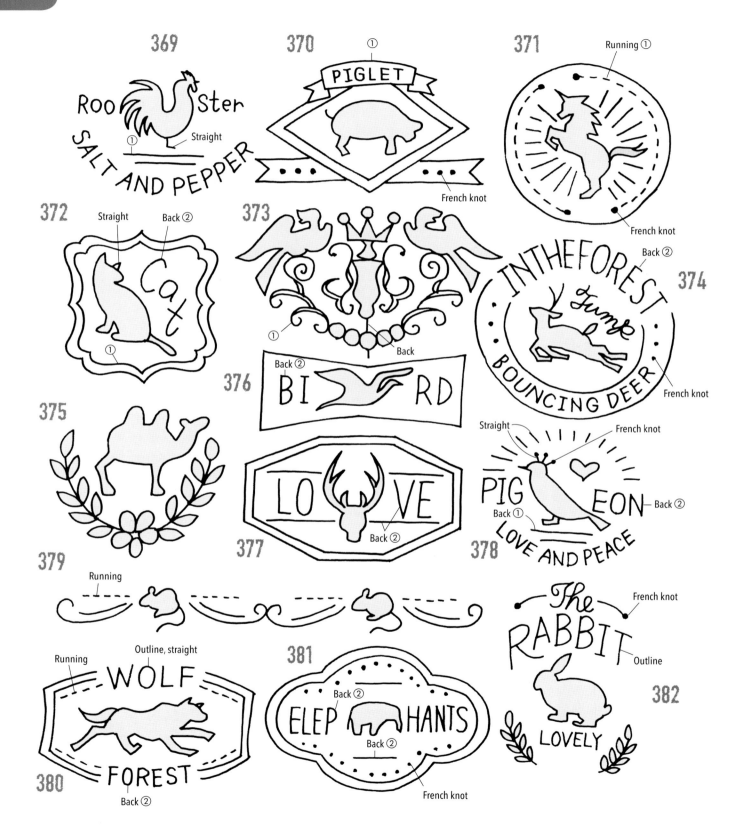

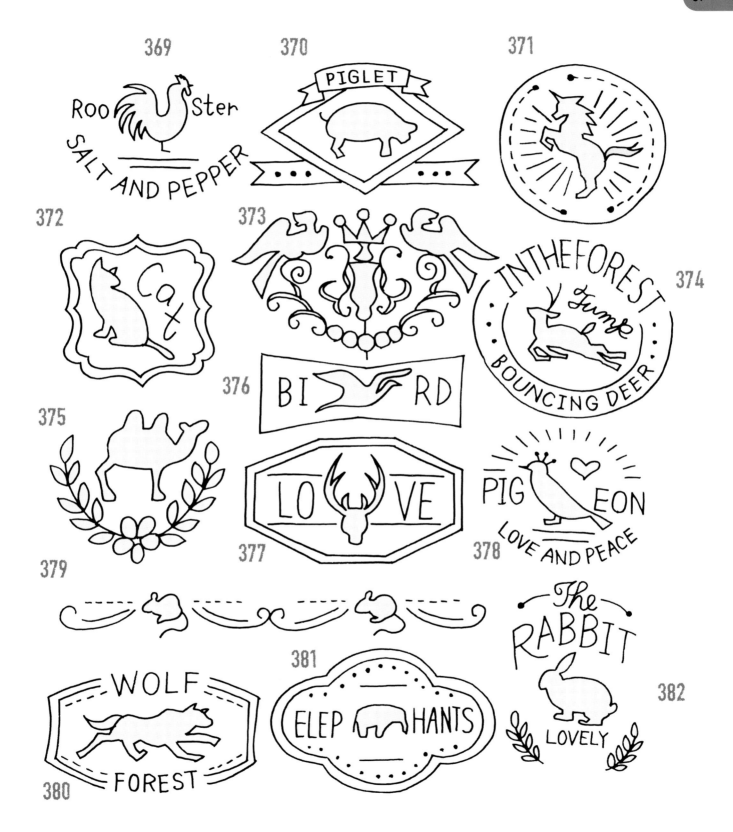

369

370

371

372

373

374

375

376

377

378

379

380

381

382

At the Circus

Photos: page 33

- ■ ◯ = Number of strands (use 2 strands unless otherwise noted)
- ■ # = Color number
- ■ Fill with satin stitch ② unless otherwise noted.
- ■ Use French knots ① 900 (wrap twice) for the eyes and ① 900 (wrap once) for the noses.

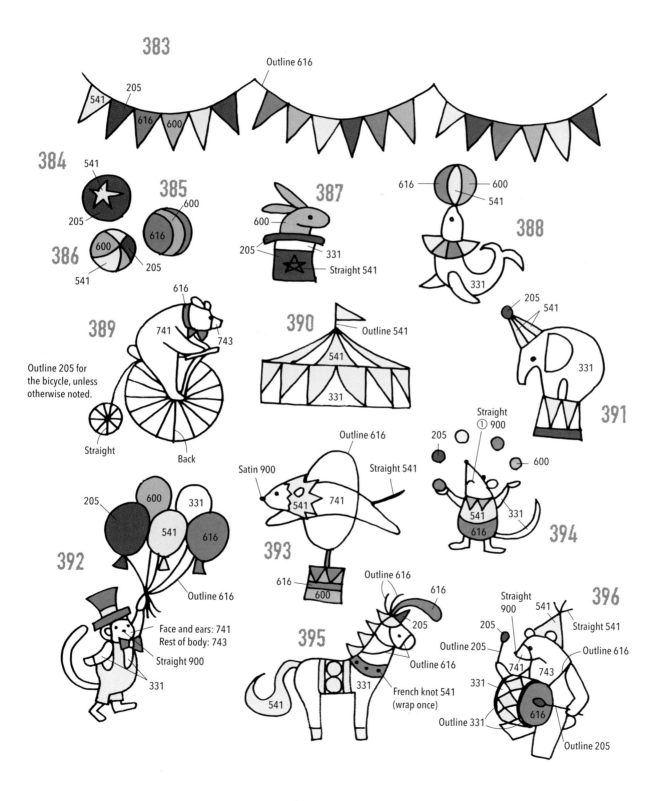

383
205
541
Outline 616
616 600

384
541
205

385
600
616

386
600
205
541

387
600
205
331
Straight 541

388
616 600
541
331

389
616
741
743
Outline 205 for the bicycle, unless otherwise noted.
Straight
Back

390
Outline 541
541
331

391
205 541
331
Straight ① 900

392
205
600
331
541
616
Outline 616
Face and ears: 741
Rest of body: 743
Straight 900
331

393
Outline 616
Satin 900
541 741
Straight 541
616
600

394
205
600
331
541
616

395
Outline 616
616
205
331
541
Outline 616
French knot 541 (wrap once)

396
Straight 900
205
541
Straight 541
Outline 205
741 743
Outline 616
331
Outline 331
616
Outline 205

383

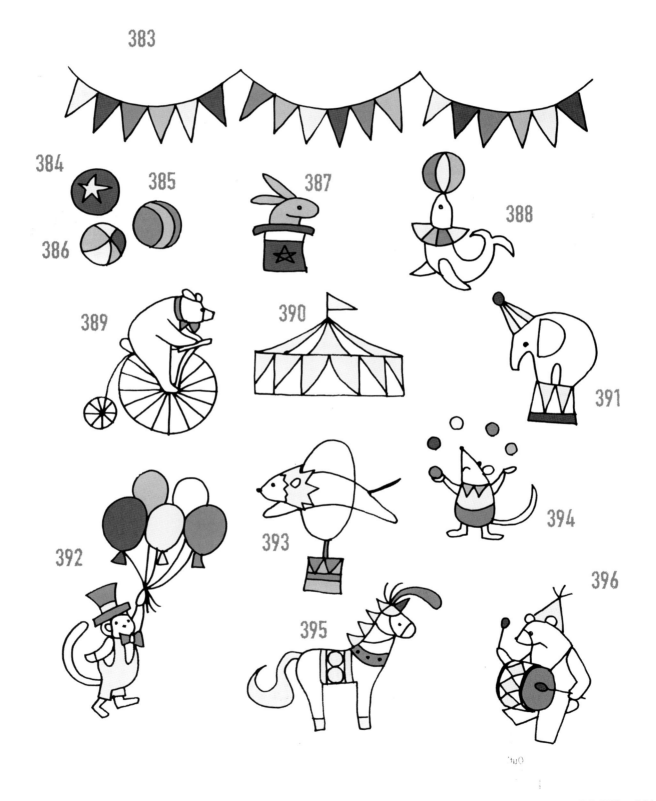

384

385

386

387

388

389

390

391

392

393

394

395

396

Animal Alphabets

Photos: page 34

- ■ ◯ = Number of strands (use 2 strands unless otherwise noted)
- ■ # = Color number
- ■ Chain stitch ③ for the alphabet.
- ■ Use French knots ① 487 (wrap once) for the eyes unless otherwise noted.
- ■ When making French knots, wrap once unless otherwise noted.
- ■ Straight stitch unless otherwise noted.

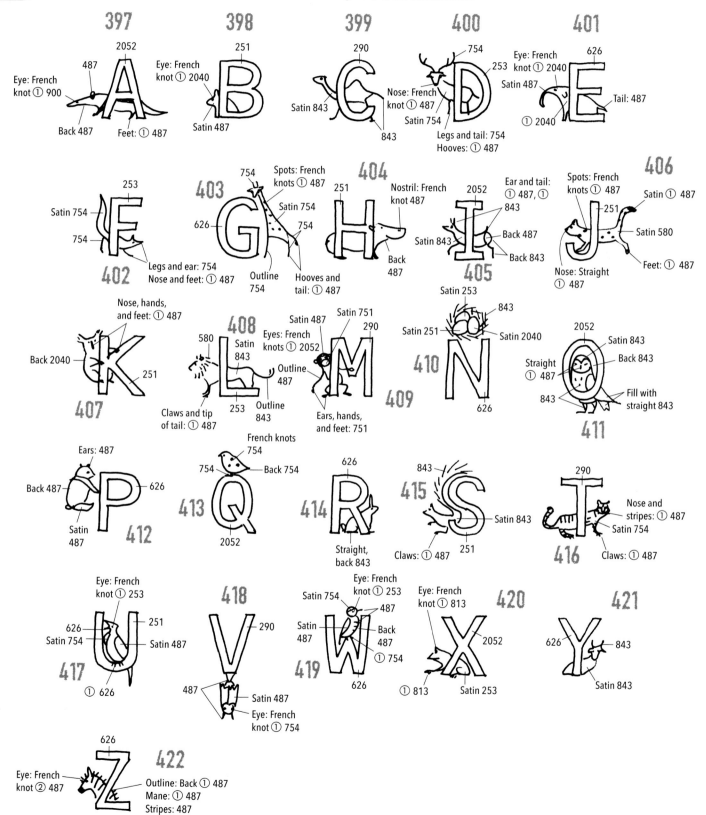

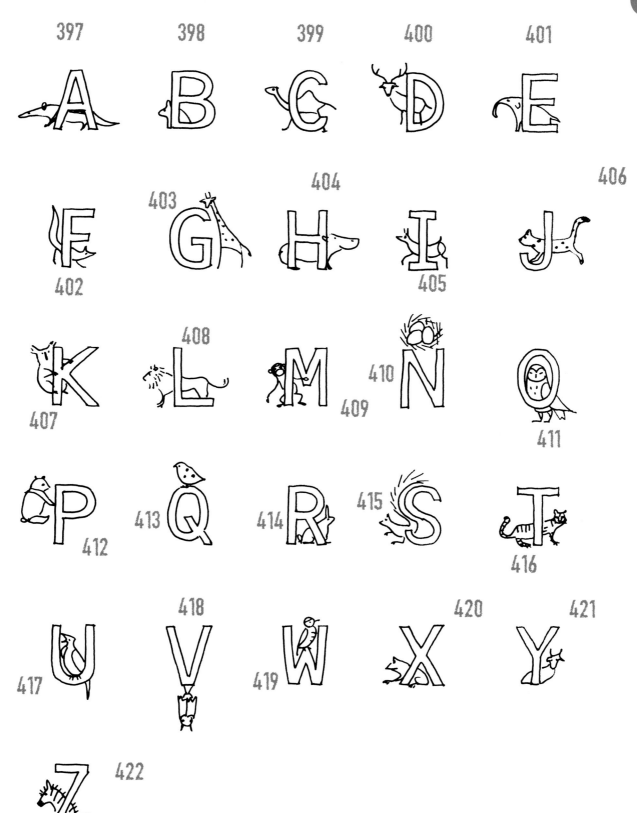

397 398 399 400 401

403 404 406

402 405

408 410

407 409 411

413 415

412 414 416

418 420 421

417 419

422

Animal Alphabets

Photos: page 35

- ■ ○ = Number of strands (use 2 strands unless otherwise noted)
- ■ # = Color number
- ■ Chain stitch ③ 253 for the alphabet.

How to Stitch the Monkeys:
Face: Satin 751, 754
Ears: French knots 751 (wrap twice)
Eyes: French knots ① 487 (wrap once)
Nose: Straight 175
Butt: 754

Limbs and tails: Outline 754
Hands and feet: Straight 751

Shirt A:
Satin 413, 580

Shirt B:
Satin 413, 2040

Shirt C:
Satin 413, 643

Back 487
Straight ① 487
Outline ③ 253
Satin 175

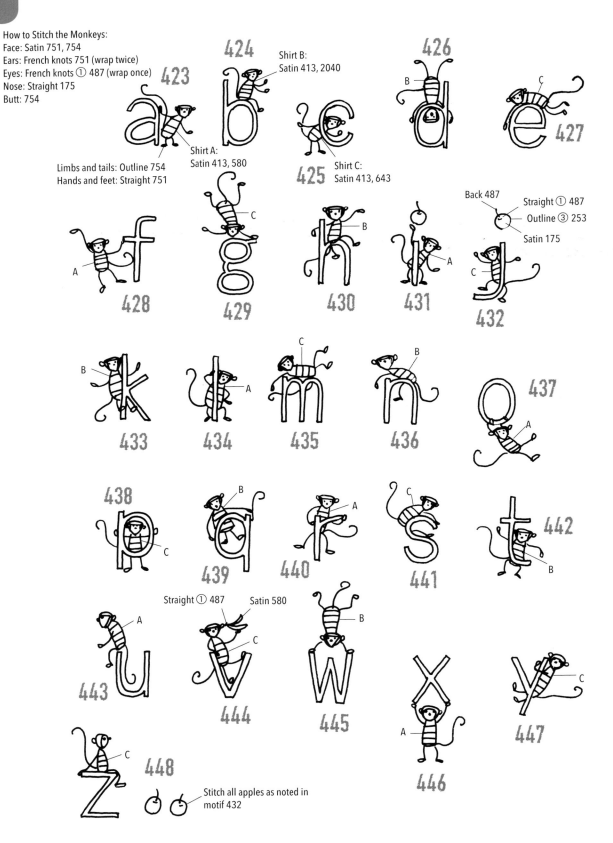

Straight ① 487 Satin 580

Stitch all apples as noted in
motif 432

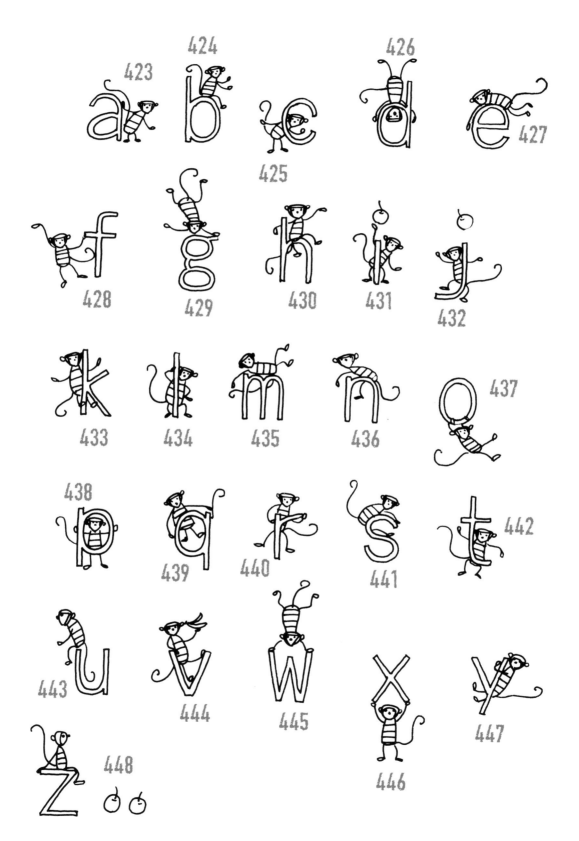

423 424 425 426 427
428 429 430 431 432
433 434 435 436 437
438 439 440 441 442
443 444 445 446 447
448

Animal Alphabets

Photos: page 36

- ■ ○ = Number of strands (use 2 strands unless otherwise noted)
- ■ # = Color number
- ■ Outline stitch ② 815 for the alphabet.
- ■ Wrap all French knots once.

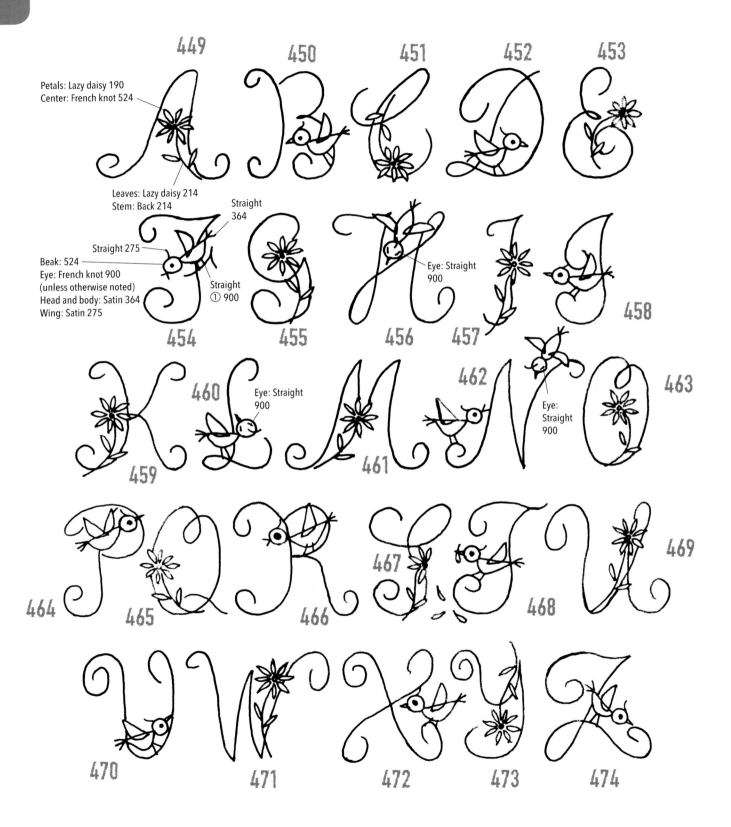

449

Petals: Lazy daisy 190
Center: French knot 524

450

451

452

453

Leaves: Lazy daisy 214
Stem: Back 214

Straight 364

Straight 275

Beak: 524
Eye: French knot 900
(unless otherwise noted)
Head and body: Satin 364
Wing: Satin 275

Straight ① 900

Eye: Straight 900

454

455

456

457

458

Eye: Straight 900

460

Eye: Straight 900

462

Eye: Straight 900

463

459

461

464

465

466

467

468

469

470

471

472

473

474

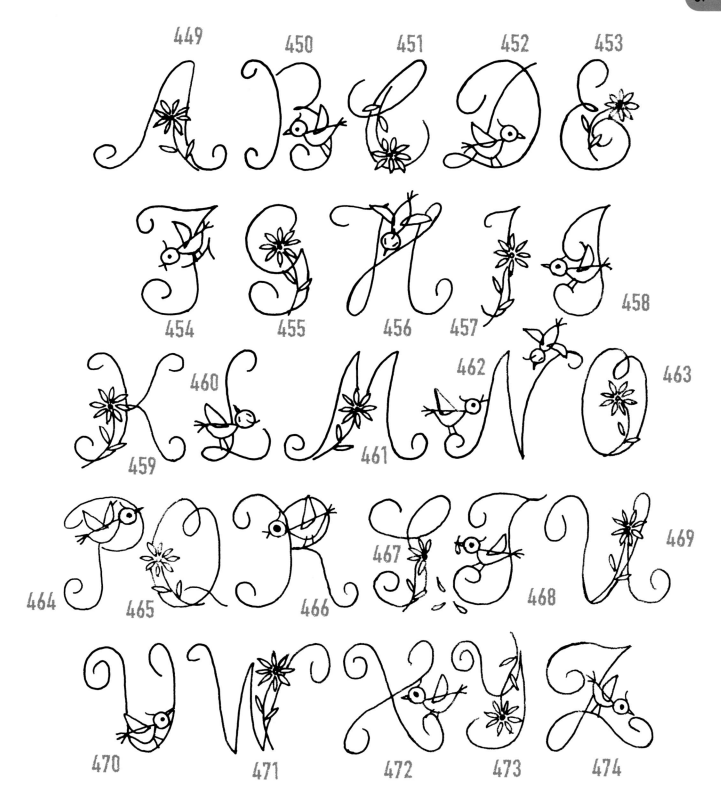

449 450 451 452 453

454 455 456 457 458

459 460 461 462 463

464 465 466 467 468 469

470 471 472 473 474

Animal Alphabets

Photos: page 37

- ■ ○ = Number of strands (use 1 strand unless otherwise noted)
- ■ # = Color number
- ■ Outline stitch ② 2042 for the alphabet.
- ■ Wrap all French knots twice.

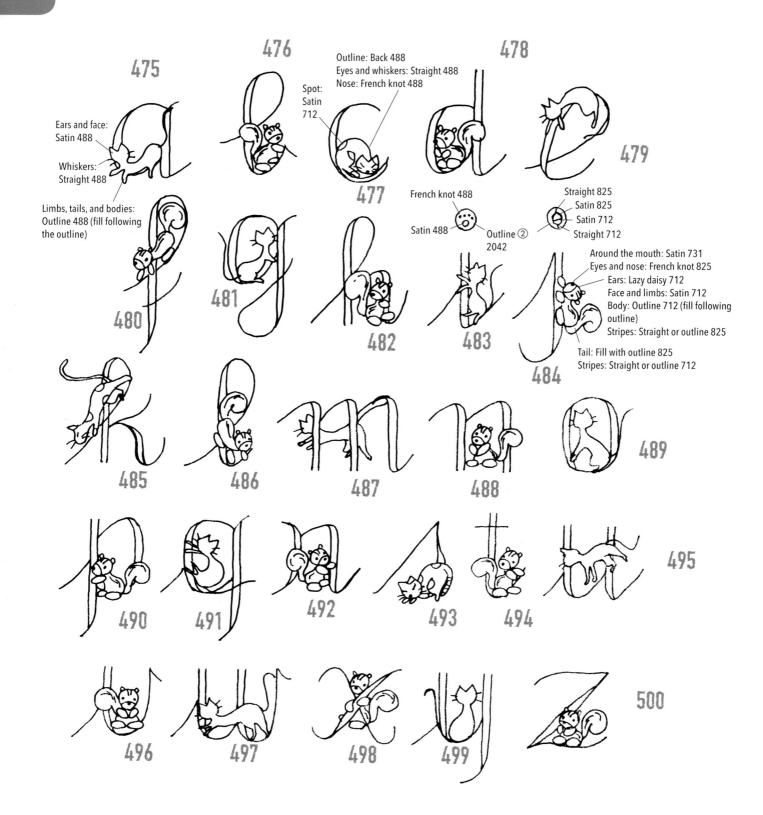

475

Ears and face:
Satin 488

Whiskers:
Straight 488

Limbs, tails, and bodies:
Outline 488 (fill following
the outline)

476

477

Spot:
Satin
712

Outline: Back 488
Eyes and whiskers: Straight 488
Nose: French knot 488

478

French knot 488

Satin 488

Outline ②
2042

Straight 825
Satin 825
Satin 712
Straight 712

479

480

481

482

483

Around the mouth: Satin 731
Eyes and nose: French knot 825
Ears: Lazy daisy 712
Face and limbs: Satin 712
Body: Outline 712 (fill following
outline)
Stripes: Straight or outline 825

Tail: Fill with outline 825
Stripes: Straight or outline 712

484

485

486

487

488

489

490

491

492

493

494

495

496

497

498

499

500

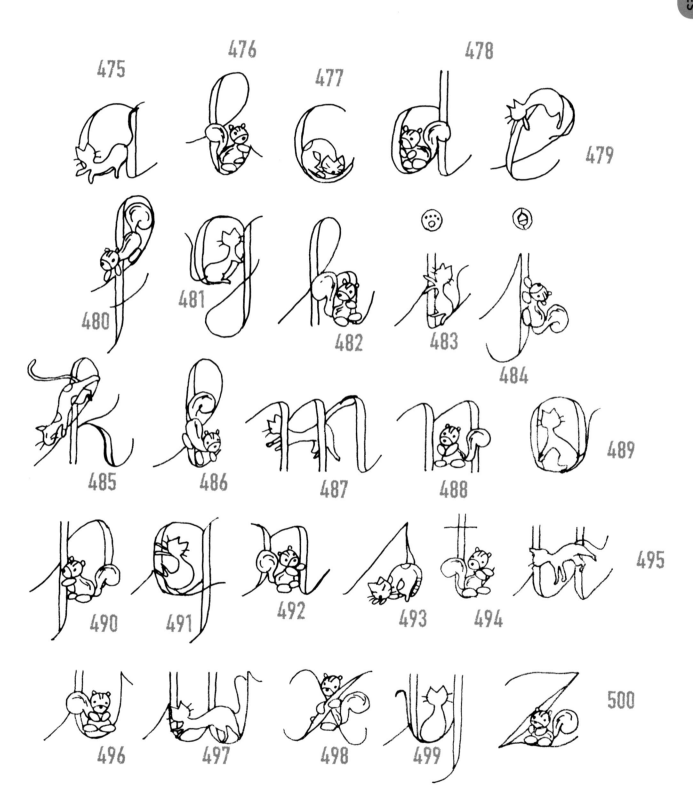

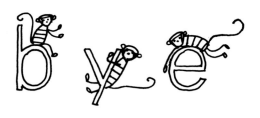